Digital
Photography

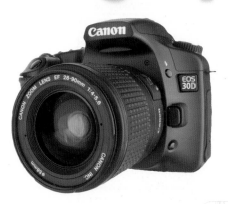

Publisher and Creative Director: Nick Wells
Project Editor: Chelsea Edwards
Senior Editor: Sarah Goulding
General Editor: Nigel Atherton
Art Director and Layout Design: Mike Spender
Digital Design and Production: Chris Herbert
Proofreader: Julia Rolf
Indexer: Penny Brown

Special thanks to: Sara Robson, Digby Smith and Cat Taylor

11 13 15 14 12

3 5 7 9 10 8 6 4 2

This edition first published 2011 by
FLAME TREE PUBLISHING
Crabtree Hall, Crabtree Lane
Fulham, London
SW6 6TY

www.flametreepublishing.com

Flame Tree Publishing is part of The Foundry Creative Media Co. Ltd

© 2011 The Foundry Creative Media Co. Ltd

ISBN 978-1-84786-982-1

Printed in China

Every effort has been made to contact copyright holders. In the event of an oversight the publishers would
be glad to rectify any omissions in future editions of this book.

Digital

GENERAL EDITOR: Nigel Atherton

Photography

**AUTHORS: Nigel Atherton, Hannah Bouckley,
Ian Burley, Steve Crabb, Jamie Harrison, Joël Lacey**

**FLAME TREE
PUBLISHING**

Contents

Introduction

The year 1839 was a good one in the history of communication. Two men, Louis Daguerre in France and William Henry Fox Talbot in England, both announced that they had managed to solve a problem that had been vexing scientists for centuries: how to record an image, and make it permanent. Thus photography was born.

At the time it was a crude, slow and highly toxic activity, but as the years went by, pioneers found ways to make it easier: glass plates, pre-coated plates, flexible film. However, by the first decade of the twentieth century the last big, revolutionary development in photography had already been achieved, with the invention of colour – though it would be decades before it was good enough and accessible enough to really take off.

The first 'digital cameras' were actually video cameras that took still photographs, and the quality was terrible. A few were sold to specialist markets, where the need for instant pictures outweighed concerns about the quality, or the astronomical cost, but they barely showed up on the public radar until the dying days of the twentieth century. Manufacturers kept plugging away, the quality got better, the prices fell lower and lower, until a point came, around 2003, when the general public suddenly realized that here was a viable alternative to their old film cameras which offered not one, but several huge advantages. Firstly, people could see the pictures they had taken straight away, and that was a revelation. If the picture was no good it could be re-shot. Suddenly, the nail-biting 'will they/won't they come out' trip to the photo processors was no longer necessary. If this was the only benefit of digital it would still be worth having, but there are many more. The removable card on which the pictures are stored can be reused. That means

that once you have bought both the camera and a decent-sized memory card, you need never spend money again unless you want to make a print.

Digital photography has moved the darkroom to the home PC. This benefit is the one which has had the greatest impact on the hobby of photography, because it gives the user an unparalleled degree of control over the final image. Even relatively inexpensive printers can produce prints that are virtually indistinguishable from silver-based prints.

For anyone who remains unconvinced, the benefits still don't end there. With the invention of the internet, digital photographs can be enjoyed in any number of ways. They can be emailed, seconds after they have been taken, to friends and relatives all over the world. They can be uploaded to one of the numerous photo-sharing websites and sorted into albums, where fellow surfers can view, rate and comment on them. Or you can build your own image-based website, to your own design.

Entry into this magical digital world has never been more accessible. High-quality digital cameras have never been cheaper, and PCs have never come loaded with more bells and whistles. But there's a snag: there is a lot to learn. Bytes, megabytes, CCDs, USBs, RGBs, JPEGs, MPEGs … And that's where we come in. This comprehensive manual covers everything you need to know, from the very basics of composition all the way to image editing. Divided into easily navigable sections, you can start at the beginning and work your way through, or use it as a handy reference guide and dip in and out of it as required. However you use this book, you will find it an invaluable companion to help you get the very best from what you will soon discover – if you don't already know – is the world's most rewarding hobby.

Nigel Atherton, General Editor

Using Your Digital Camera

How Digital Cameras Work

Digital cameras are complex electronic devices that perform many functions and calculations every time you press the shutter button. Unlike film, the information recorded is not held as a tangible, physical entity, such as a negative. Instead it records data, a series of binary numbers that a computer can read. So how does this happen?

When you press the shutter button on a digital camera, several things happen. The shutter opens and the subject is captured on a digital sensor or CCD (Charge-Coupled Device) – essentially the digital version of film. The CCD is a small silicon chip holding millions of tiny light-sensitive elements, called pixels. These are arranged in a grid and receive the individual particles of light, called photons, which are turned into an electric charge by the sensor. At this time this electric signal is still in an analogue form. These signals are sent to the camera's processor, a small computer chip that turns the signals into binary code (a series of 1s and 0s) which is then saved in a format that a computer can read. The file that is created is then saved to a memory card, a small, removable storage device in the camera.

Camera Judgments

That is the basic science, but much more goes on. As you press the shutter, the lens focuses on the subject while the sensor measures the amount of light, so that the exposure will

⬆ *Image files are stored on memory cards in the camera.* ➡ *The sensor is the digital version of a roll of film.*

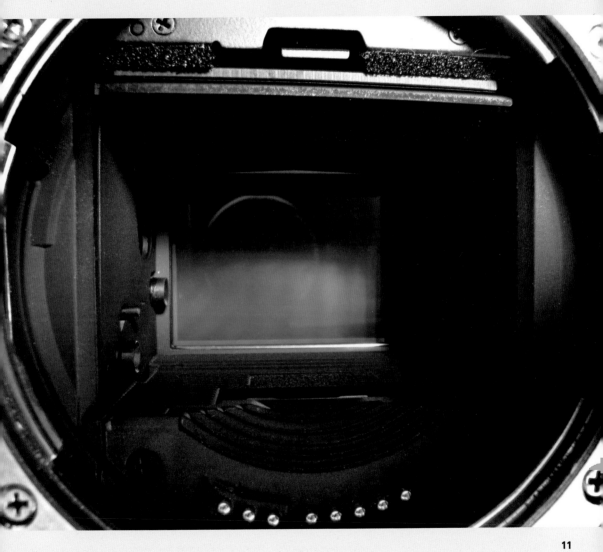

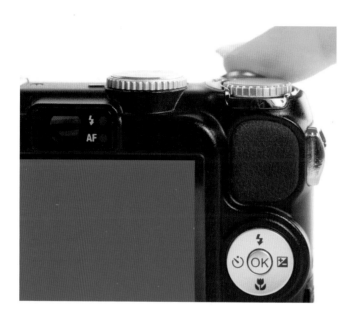

be correct. It also measures the colour of the light, so that it is replicated accurately. This process, known as white balance, is added at the processing stage. Other processes are also added to the image – sharpness, contrast correction, etc. – using mathematic formulae known as algorithms, designed by the camera's engineers.

File Compression

Finally, in order to keep the file size small enough to keep the workflow and memory working efficiently, the file is usually compressed. This involves the camera processor

looking for areas of similar colour and detail in the image and throwing some of that information away, thus reducing the file size. This results in a JPEG file, and when the file is opened on a computer, the computer then replaces that information and increases the size of the file again. The JPEG file is then saved on the memory card, and the camera is ready to take the next photograph.

⬆ *A JPEG is an image file.* ⬆ ➡ *Half pressing the shutter button gets your shot in focus.*

Anatomy of a Digital Camera

Digital cameras share many of the same functions as traditional cameras, but have lots of new features that you need to become familiar with. Here is a brief rundown of the most common features found on a digital camera.

Lens

One of the key elements of any camera, film or digital, the lens directs the light from the subject to the sensor. It is used to focus on the subject, ensuring sharpness. Most digital cameras use a zoom lens, which has several focal lengths and changes the size and perspective of the subject being photographed.

Power Switch

Turns the camera on and off.

Shutter Release Button

Operates the camera shutter, a small door that opens inside the camera to expose the sensor to the image projected by the lens. Half pressing the shutter release button also operates the autofocus and initiates the light meter, which measures the light and calculates the exposure.

LCD Monitor/Menu

Images can be composed and reviewed on the LCD (Liquid Crystal Display) monitor. The camera's menu is also viewed on the monitor. The menu is a series of screens and sub-headings that allow you to make changes to the way your camera functions.

➡ *Digital camera front, showing the lens, flash and viewfinder.*

Flash

Photography uses light to record the picture. If there is no light, you cannot take a picture. Most cameras have a built-in flash to add light in the dark. The flash can also be used in bright sun to eliminate unwanted shadows.

Mode Dial

Chooses different exposure modes or scene modes, which alter the way the camera takes the picture. You will also usually find a video mode here.

Navigation Buttons

Usually there is a cluster of four buttons, or a rocker switch, that navigate through the menu and make changes. The arrow keys also scroll through the pictures you have already taken when used in review mode. Often the buttons will have a

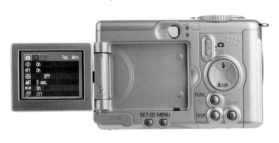

secondary purpose to operate other features on the camera such as the flash, self timer and macro mode.

Viewfinder

A small lens set into the camera to compose images without using the LCD. Many compact cameras now don't have a viewfinder, relying on the LCD monitor instead. However a viewfinder is useful in bright sunlight when it may be difficult to see the LCD clearly.

Zoom Control

Usually a rocker switch or pair of buttons that operate the zoom function of the lens. It is also often used to magnify images displayed in review mode.

⬆ *LCD monitors have become increasingly sophisticated* ➡ *The mode dial allows you to change the way the camera takes the picture.*

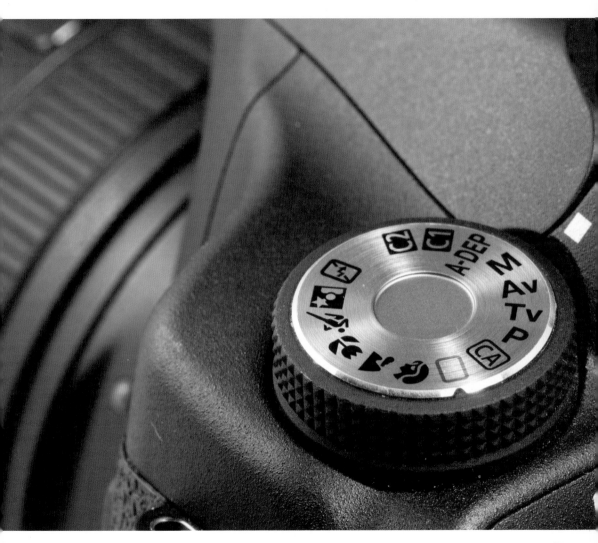

Types of Digital Camera

Whatever your level of experience or your style of photography, there is a camera out there for you. There are several major categories of digital camera, although a few cross over.

Camera Phones

These are a recent development but are a very popular imaging device. Image quality has been poor for a long time, but they are rapidly improving, with larger sensors, better lenses and features including autofocus, white balance and more. Camera phones are many people's first introduction to photography and encourage people to take pictures, but with a few exceptions are not used as a serious photographic tool.

Entry Level Cameras

These are usually cheap and cheerful, with plastic bodies and simple controls. They often have a fixed lens with no zoom and a basic automatic exposure mode, although as prices fall manufacturers are adding more features.

⬆ *Digital cameras are improving all the time.* ➡ *A hard-wearing metal body can be worth paying extra for.*

Lifestyle Compact Cameras

Digital photography has freed camera designers to create much more stylish models. The smaller electronic components and lack of film chambers has resulted in some attractive and occasionally radical designs. Cameras can be the size of credit cards and come in many different colours. Lifestyle cameras vary wildly, with some models offering just basic controls to point and shoot, or more advanced exposure controls to appeal to the enthusiast.

Superzoom Cameras

Superzooms are very versatile. They have long zoom lenses and usually a combination of exposure modes to suit everybody from the family snapper to the photographic enthusiast. Superzooms are usually larger than compact cameras, due to the size of the lens, but are still lightweight and small enough to be carried in a camera bag.

Digital SLRs

The SLR (Single Lens Reflex) is the most versatile of cameras. Usually aimed at the more competent, enthusiastic photographer, as well as professionals, SLRs offer high quality images with lots of control. Different lenses can be used, along with a wide array of accessories. SLRs are larger than other cameras, and as you build a system with extra lenses and accessories they can become bulky and heavy to carry around. If you are serious about photography, however, the SLR is the best choice.

⬆ *Some designs come in a variety of colours.* ➡ *SLR cameras are a great investment if you are serious about photography.*

Resolution

One of the first considerations when buying a digital camera should be its resolution - the amount of detail the camera can capture via its sensor. Commonly measured in megapixels, resolution has long been a competitive issue amongst camera manufacturers. There is an assumption that the more megapixels the better, but this is not always the case.

The word 'pixel' is short for 'picture element', a tiny light sensor that is the basic element of a digital photograph. They make up an image much like individual tiles make up a mosaic. If you put a million of them together you have a megapixel. Each pixel translates to one pixel on a computer screen.

Pixels record the colour of an image as red, green and blue, commonly known as RGB. When the colours are all mixed together on a screen they form the multi-coloured image, in the same way as the image on a TV is formed.

Megapixel Requirements

Most cameras now offer at least three to five million pixels resolution, which indicates the level of detail a

⬆ ➡ The lower the resolution, the more pixellated your photograph will be.

camera can capture. This is important when it comes to printing, as the more detail an image has, the larger and sharper the prints will be. For the average user, five or six million pixels will produce good results up to A4 on a home printer or from a high street laboratory.

Compacts with more megapixels are available, but they produce larger sized files, which take up more space on your memory card and on your computer's hard drive. For the average home user printing 6 x 4 inch prints (the most common print size from a lab), the extra resolution would make little difference to the final print. If larger prints are needed then a higher pixel count is necessary.

Quality Over Quantity

Resolution alone is not the whole story, though. The more pixels that camera manufacturers cram on to their sensors, the smaller those pixel sites have to be. A smaller pixel site will gather less light than a larger pixel site given the same exposure. This means that either these chips are less sensitive or that their built-in image processors have to amplify the signal from the pixel site. This also amplifies any non-image forming noise, which shows as false coloured pixels in the final image. As a general rule, therefore, cameras should always be judged by what their pictures are like, and not by how many megapixels they boast.

⬆ *Larger prints require a higher pixel count to maintain quality.* ➡ *Larger file sizes will use more space on your memory card and hard drive.*

Lenses

The lens is crucial to digital photography, as it is the means by which light enters the camera in order to record the image to the CCD. The lens is also used to focus the image so that it is sharp, and plays a critical role in determining the look of the image – the composition and perspective.

The lens is essentially a series of curved glass elements that are set into a complex mechanism. They move in relation to each other to provide the best focus for any subject at any given distance.

With very rare exceptions, all digital cameras use autofocus lenses, which automatically detect the subject and lock the focus on it. Most compact digital cameras also use zoom lenses, which offer different focal lengths (the distance in millimetres from the centre of lens to the point of focus) to allow subjects to appear closer and for perspective to change. SLRs accept different lenses, which can be changed as the situation, or personal choice, requires. Different lenses offer different focal lengths and there are four main types of lenses available for digital SLRs.

⬆ Zoom lenses enable you to focus in on a particular feature. *➡ A useful accessory, zoom lenses are very versatile.*

Standard

Offers a similar field of view to the human eye. Typically this is the equivalent of a focal length of 50 mm.

Wideangle

Produces a wider than normal field of view allowing more of the scene to be captured in the frame, which makes objects look smaller (and thus further away) than they really are. Wideangle is good for capturing landscapes or buildings, and the increased perspective can be used to add drama.

Telephoto

Has a longer focal length and is used to make subjects look bigger (and thus closer) than they are. Short telephoto lenses are good for producing natural portraits, while longer lenses are good for sport and wildlife photography. Perspective is decreased in telephoto lenses, making the subject look closer to the background.

Zoom

Offers a combination of focal lengths and can stretch from wideangle through standard to telephoto. The advantage of the zoom is that one lens fits all, offering versatility as well as convenience.

Most digital cameras have a smaller image area than traditional film cameras do – i.e. the sensor is smaller than a 35 mm film frame, so smaller focal lengths are needed to achieve the same effect as on 35 mm film. However, because 35 mm has been prevalent for so long, many manufacturers quote 35 mm-equivalent focal lengths as a shorthand for consumers to understand the effect of any given lens.

➡ *Wideangle works well with low angles.*

Viewfinders & LCDs

Before you take a photograph, you need to compose your scene. To do this you need a viewfinder or a monitor.

Optical Viewfinder

The most popular form of image composition has long been the viewfinder. On compact cameras this is usually a small lens fitted to a bore hole through the casing of the camera. It is usually off-centre from the lens but is also linked to it, so as you zoom the lens, the magnification of the image in the viewfinder increases. The problem with this

type of viewfinder is that the image you see is not the same as the image seen by the lens, and some compositional control is lost. In addition, optical viewfinders do not show much shooting or exposure information. They are rapidly disappearing from newer digital cameras to be replaced by LCD monitors.

Reflex Viewfinder or Pentaprism

With SLRs, the image seen through the viewfinder is exactly the same as that of the lens thanks to a series of prisms and mirrors. Reflex viewfinders are large and bright and show most shooting

⬆ *In EVF mode, the image is shown exactly as the lens sees it.* ➡ *This type of viewfinder does not show the image exactly as the lens sees it.*

information using LED (Light-Emitting Diode, or small light) readouts around the outside, as well as metering and focusing points within the frame. They don't allow video shooting, however, as the mirror is in the way, and the finder goes black at the time of capture. This is because the mirror has to be lifted to allow the light waves to pass through to the CCD.

Electronic Viewfinder

The Electronic Viewfinder, or EVF, has gained in popularity on superzoom cameras in particular. Like a reflex viewfinder it shows the image exactly as the lens sees it, but as a video feed on to a small screen direct from the CCD.

Small amounts of video footage can therefore be recorded and an array of camera data and information can also be superimposed over the viewed image. Resolution can be poor, however, and slow video refresh rates can make the view seem jerky.

LCD Monitor

Arguably the most important development in digital photography, the LCD (Liquid Crystal Display) is taking the place of optical viewfinders on compact cameras. Like the EVF it offers live video feed, and screens can be large, some almost filling the back of the camera. However, LCDs are notoriously difficult to see in bright light, and by moving the camera away from the eye to a position where the screen can be seen, camera stability is reduced. This may lead to blurred photos and tilted horizons.

⬆ *Electronic viewfinders show the image on the LCD screen.* ➡ *This LCD display takes up a lot of the back of the camera.*

Menu Functions

A camera's menu is a vital element that can completely change the way your camera works. It is the means by which you can make changes to exposure, image size and much more. The more sophisticated models have extensive menus with functions you didn't even know you needed.

When you access your camera's menu, a series of lists will appear on the LCD that allow you to set up the camera exactly the way you want. This can be performed for one shot, or saved as your default for all of your pictures.

Most cameras divide the menu into three categories, or modes, with separate, more specific modes within.

Set-up Mode

This menu should be the first one you access after buying a camera. You can set the camera's date and time, useful so that years later you can see exactly when a picture was taken. You can also set the video output to match the system used where you live. 'Format' lets you set the format

⬆ *The camera's menu should be easy to navigate.* ➡ *The set-up mode allows you to change the camera's basic settings.*

 Set up

Mute	On Off
Volume...	
LCD Brightness	
Power Saving...	
Date/Time...	24.01.'06 14:11
Format...	CF 1.8GB

of the pictures on your memory card and also optimizes the saving efficiency of your card for the particular camera you own.

Picture/Shooting Mode

This allows changes to the way the camera takes pictures, and the submenus will change the look of your photographs. Common items include image quality, to change the resolution or file type of the image; metering, which changes the way your camera measures the light; digital filters which alter the colour, sharpness and contrast of the images; exposure compensation, to make pictures lighter or darker; and white balance, which can be set to match the exposure to the colour of the light source.

Review Mode

In review mode, you can change the way the camera shows you your pictures. You can usually choose the amount of time that an image is shown on the LCD immediately after a picture is taken. You could choose to display pictures as a slideshow, or a series of small pictures in a grid, called thumbnails. You can tag, or digitally pick, individual pictures as favourites either so that they can't be deleted or for printing later. You can also delete pictures you don't want.

⬆ *Some modes allow you to take account of the quality of light.* ➡ *It is easy to alter the ISO speed with a digital camera.*

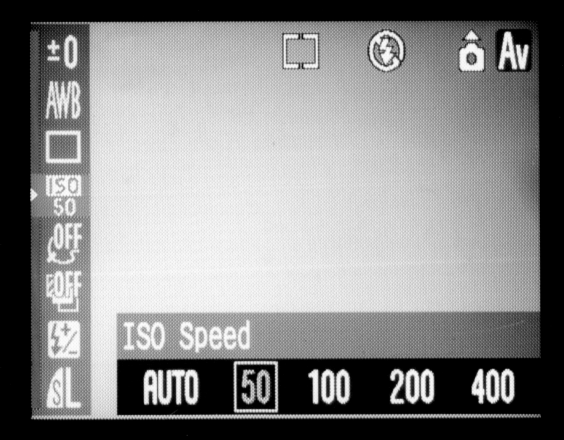

ISO Speed

AUTO 50 100 200 400

Flash

It is unusual to see a camera without flash these days. Ideal for taking pictures indoors or reducing harsh shadows in bright light, flash is one of the most used features on any camera. When used properly flash can vastly improve pictures, but incorrect use can completely spoil them.

There are several different types of flash, but the most common is the one built into the camera. Although not massively powerful, for the average snapshot they are extremely useful. When the flash is dedicated to a particular camera, the exposure and flash output are automatically set, but most cameras have a choice of flash modes and it is worthwhile exploring them.

Auto

In this mode the camera will recognize when the flash is needed and automatically turn it on, as well as set the exposure and colour balance. This is ideal for general use, but can result in red eye.

Auto with Red Eye Reduction

This works in the same way as the auto mode, but it will also fire a burst of flashes before the picture is taken in order to make the subject's pupils smaller and reduce the effect of red eye. This works reasonably well, but red eye can still occur. It also slows down the operation of the camera, as it can take a second or two for the burst to fire. This can lead to the subject having their eyes closed (as the preflash triggers a blinking reaction) and less-natural facial expressions.

➡ *The flash menu allows you to reduce the effect of red eye.*

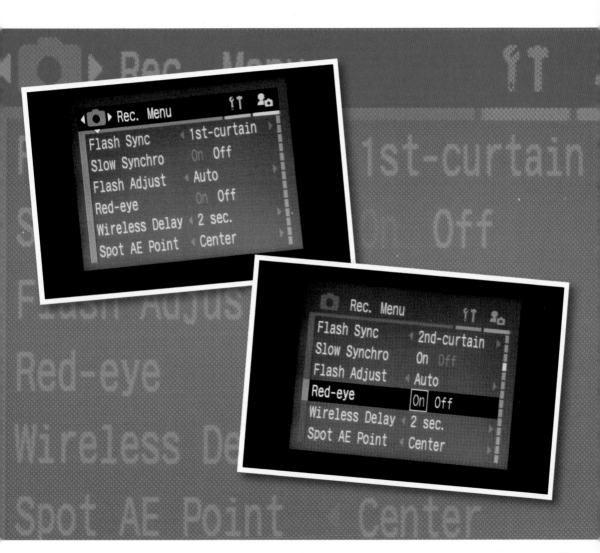

Flash Off

There may be occasions when you don't want the flash on, either for creative reasons (you may want to use the natural light) or because you are shooting candid portraits and don't want to alert the subject to your presence. There are also places, such as art galleries and churches, where flash photography is forbidden. When the flash is switched off, the camera compensates by setting a slower shutter speed to obtain correct exposure.

Flash On

This is the manual flash mode, sometimes called fill or forced flash. In this mode, the photographer decides whether to turn the flash on as and when it is needed. This is a useful mode if the sun is behind the subject, or if bright sunlight is causing harsh shadows. Using flash will 'fill-in' those dark areas.

Slow Sync

Slow sync, or synchronization, fires the flash whilst using the same shutter speed and aperture as if the flash were not being fired. This is useful at night when a longer exposure is needed to capture the ambient light, while at the same time the flash exposure illuminates the subject. Slow sync can also be used to freeze a moving subject while leaving movement trails. Second curtain sync is another version of this, where the flash fires just before the end of the exposure. This makes movement look more natural, with a moving subject being frozen sharply at the front of a movement trail.

↑ *Slow sync freezes a subject and leaves movement trails.* ➡ *You may want to turn the flash on if the sun is behind your subject.*

Memory Cards

Once you have taken your pictures, they need to be stored somewhere for later printing or copying to your computer hard drive. For this you need a memory card, often called a media card, and there are several different types.

When you first buy a camera you may get a memory card with it, or the camera may come with some memory built in. This is enough to get you started, but will only allow a small number of pictures to be stored, so you will need to buy a decent capacity memory card as soon as possible (it may work out cheaper if you buy it with the camera). There are several different types of memory card so you need to make sure you buy the right one for your camera - consult your instruction book or ask in a camera shop if you are unsure. Always buy the highest capacity card you can afford, as this saves having to change cards often and possibly losing the full one you just took out. This is even more important if you habitually shoot video on your camera.

Secure Digital (SD)

By far the most popular type of card, SD is small and offers high capacity and fast write times. It is compatible with many other digital devices such as MP3 players and TVs. SD cards come in several

⬆ *A memory card can hold hundreds of images.* ➡ *When transporting your memory card, keep it safe in a case.*

varieties. SDHC (Secure Digital High Capacity) is a newer type of card which offers capacities up to 32 GB, while the newest incarnation, SDXC, can go up to 2 TB. Although physically the same size, there is no backward compatibility – though you can use standard SD cards in SDXC-compatible products. A smaller version, Micro SD, is used in many mobile phones, and now even some cameras.

Compact Flash (CF)

Once the card format of choice, the larger Compact Flash card is now restricted to use mainly in professional digital SLRs. More recent CF cards use UDMA protocol, which enables the reading and writing of data at much faster speeds than older cards, making them ideal for the high demands of pro sports photographers and the like. Compact Flash cards are currently available in capacities up to 64 GB.

Extreme Digital (xD)

Formed as a collaboration between Fujifilm and Olympus, and used exclusively in their cameras, xD cards are even smaller than SD cards. However, the all-conquering popularity of SD means that even Fujifilm and Olympus are starting to incorporate SD card slots as well as, or instead of, xD in their latest cameras and it is likely that xD's days are numbered.

Memory Stick (MS)

Despite the common but erroneous use of the term memory stick to describe any kind of memory card, and even USB pen drives, a Memory Stick is actually Sony's proprietary card format and is used only in Sony cameras. There are various varieties of Memory Stick including MS Pro, MS Pro Duo and MS Micro (used in phones), but like xD it is under threat from its bitter rival, SD, as Sony has started incorporating SD slots into its newer cameras.

➡ *Buy the highest capacity memory card you can afford.*

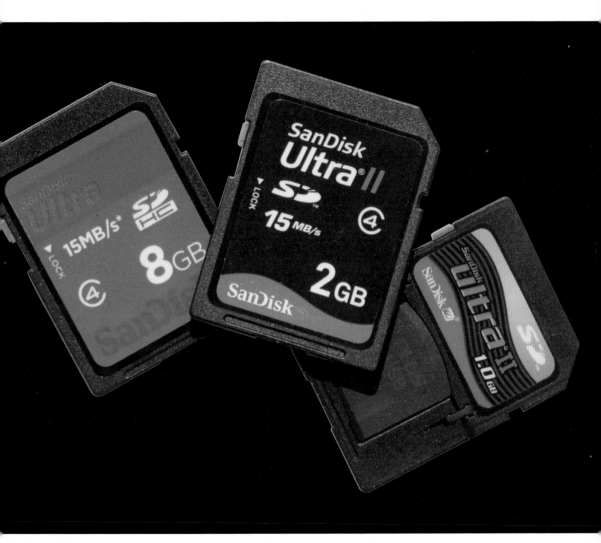

Camera Phones

Early camera phones had very low resolution and poor control, but recent models are vastly improved to the point where many people now use them in preference to a proper camera. However, compact cameras have been improving too, so is it still worth using one in preference to the camera in your phone? It depends on your needs.

For many people mobile phones offer their first experience of digital photography, and if you compare the specs of the latest camera phones with budget compact cameras it's hard to see what the disadvantage is. After all, many phones offer resolution in excess of 12 megapixels, which is comparable to many cameras. Some camera phones have premium lenses from the likes of Carl Zeiss, and a few even have a flash.

Camera Phone Drawbacks

However, while a camera phone is great to have as the camera that is always in your pocket, and is ideal for quick record snaps, there are limitations. For a start a camera phone is, first and foremost, a phone. This means that it has lots of features and numerous buttons that have nothing to do with the camera, such as the keypad. This affects not only the ergonomics of using the phone as a camera, making it a bit more fiddly and awkward, but the time it takes to access the camera part of your phone and wait for it to power up can be several seconds. It also means that the internal space that can be given over to the camera's circuitry is smaller. As a consequence, although the sensor may have lots of pixels its physical dimensions are minute compared to a camera sensor, and this affects the picture quality. Small sensors have small pixels and

➡ *Digital photography options on phones are increasing rapidly.*

small pixels are less efficient at gathering light, resulting in noisy granular images, especially in low light. If you are lucky enough to have a flash it will be small and low-powered, so not a great help.

Camera phones will have smaller processors too, which means, among other things, that it will take longer to power up and longer to process each picture before you can take another, making them unsuitable for action. The small lens will be prone to distortion, flare and chromatic aberrations that affect image quality, and the only zoom will be digital rather than optical, which further degrades quality. There is also the issue of power – use the camera too much and you'll deplete the battery, making it useless for its primary function of being a phone.

Useful Camera Phone Features

But for static subjects in good light a camera phone will produce a competent record and you'll probably have lots of built-in features to enhance and share your pictures. These include the possibility to adjust brightness, contrast and colour, crop, make a black and white version, add funky borders or captions and so forth. You will also be able to share your images directly by emailing them or sending them to friends' phones, or posting them on social media sites. You can also print directly from the phone via Bluetooth. None of these things are possible using the average compact camera. All this of course is in addition to using a USB cable or card reader to transfer the images to your PC.

⬆ ➡ *Pictures from your camera phone can be downloaded to your computer or sent to another phone quickly and easily.*

The Aesthetics of Photography

To be a good photographer it is necessary to master both the aesthetic and technical aspects of the medium. The aesthetic part is whether or not the picture is pleasing to the eye – and this is determined by several factors: the light, the choice of subject, the expression (if it is a portrait) and the composition.

Choosing the Composition

The term composition refers to the elements you choose to include in the viewfinder, or on the Liquid Crystal Display (LCD) screen, and how you arrange them. Good composition involves thinking for a moment before pressing the shutter, taking a

quick look around the frame and deciding if the picture can be improved by zooming in or out a bit more, by moving the camera slightly up, down or to the side, by finding a higher or lower viewpoint, by moving closer or further away, or by tilting the camera, perhaps to the vertical format. You make these decisions every time you take a picture, even if only at a subconscious level, but paying more attention to these processes will result in much better composition.

⬆ *Capturing the effects of a sunset will change the whole tone of your image.* ➡ *Unusual architecture can make a great photo.*

Choosing the Lighting

The other main factor influencing a picture's aesthetics is the lighting. How is the light falling on the subject - hard and shadowy, or soft and diffused? Is it a warm or cool light? From which direction is it coming - from the front, side, above or behind? If you are photographing in natural light you cannot easily change its position but you can change your position in relation to it. By moving round to the other side of a building you can shoot the sunny side or shady side, by asking a person to turn around you can get the sun behind them instead of shining in their eyes. By coming back to the same spot at a different time of day you will get a completely different type of light altogether.

Technical Points

The technical aspect of photography involves setting the lens, aperture, shutter, and the various digital functions, such as resolution, compression and ISO sensitivity (the International Standards Organization setting that adjusts how sensitive the camera is to light) to obtain a good result. Modern digital cameras can control all of these technical features automatically, but these also all have a bearing on the aesthetics of the image, so if you leave all these decisions to the camera you are not completely in control over the final image. An understanding of these technical aspects can be used to create visually pleasing images, rather than just records of events.

⬆ *Composition is crucial to photography.* ➡ *Symmetry in your subject will make for an interesting picture.*

Composition: **Rule of Thirds/Symmetry**

Since the days of Ancient Rome, artists, architects and great thinkers have pondered what makes a building or a picture visually pleasing and have attempted to explain it with the use of mathematical and geometric principles. These principles can determine the ideal shape of a painting, and where the important elements should be positioned within the canvas for the most harmonious effect.

Although it may seem odd to apply mathematical rules to art there is some validity to it, which is why great artists from Leonardo da Vinci to Salvador Dalí have followed them to some extent. Even the image proportions used by most cameras today are based on the classic compositional ratios of 5:4 and 3:2. Picture frame sizes follow these ratios too.

Explaining the Rule of Thirds

The most useful of these mathematical and geometric principles is known as the Rule of Thirds. Imagine dividing your picture area into a grid of two horizontal lines and two vertical ones, all the same distance apart – like a noughts and crosses grid. Each line will be one third of the way in from either the top, bottom, left or right side. The Rule of Thirds says that you should place important elements of your scene on those lines. The real 'hot spots' are the four points where those lines intersect. So when photographing a person in a scene, rather than placing them right in the middle of the frame (which is what most amateur photographers do) you should put them one third of the way in from one side. With a landscape, that big tree or windmill should also be on one of the thirds, and the horizon should be placed on the upper or lower third.

➡ *Balance your composition with different elements.*

Think Outside the Box

This rule works surprisingly often, but as with most rules there is a danger of following them too slavishly so that they become dogma. If used repeatedly and relentlessly a set of pictures will eventually begin to look repetitive and boring. It is also the case that, while the rule of thirds creates a sense of harmony in your pictures, harmony is not always what you want to convey. Sometimes it is better to strive for a sense of drama, impact and discord.

The best way to achieve this is to deliberately break the rules, such as placing a subject right in the middle of the frame. When combined with a wideangle lens, for example, this can produce a great in-your-face effect. Centred subjects look especially effective if you introduce an element of symmetry to your composition, whether by arranging objects, altering your position or using devices such as reflections in water.

⬆ *Sometimes centering your subject produces the best result.* ➡ *The subject of a photo often looks better a third of the way in.*

Composition: **Geometry (Lines, Shapes & Patterns)**

The eye is an undisciplined organ. Without guidance, it will wander all over the place, never entirely deciding what to settle on. With modern computer technology it is possible to track the movement of the eye and plot its course as a line. You may have seen the resulting images produced by this technology, which resemble pictures that have been scribbled over by a hyperactive toddler. This wandering is intensified when the viewer is confronted by an image whose focal point is unclear.

Guiding the Viewer

It is possible, and desirable, to use elements within your scene to guide and corral your viewer's eyes in a specific direction. In Western culture, where books are read from left

to right, the human eye instinctively enters a picture from the left and travels across it. It would be wonderful if you could compose your shot to provide a long path, road, fence or wall running across the picture from left to right, with an interesting landmark or geographical feature at the end of it, so that the viewer's eye can follow the line through the picture and get a visual reward at the end. The human eye likes to be guided like this, and told what to look at.

⬆ *Sweeping curves are aesthetically pleasing.* ➡ *Use the subject to guide the viewer's eyes in a specific direction.*

Making Use of Lines

Learn to look at your subject not as what it actually is, but as a series of shapes and lines. In your head, mentally draw it - a long straight line here, a big curve there, a wavy line over there - and by changing your position or zooming in or out, use those lines to guide the viewer around the image. Diagonal lines create drama, and those coming from the bottom left lead the eye into a shot. Try not to let the eye wander out the other side of the picture without resting on anything. Also, don't forget to make the most of sweeping curves wherever you find them, which can add a sensual, feminine quality to your picture even if they are only hills, or rocks in a pond.

Making Use of Patterns

Repeating lines and shapes is good too. They create a natural pattern or grid, which conveys a sense of order. We are not often aware of patterns in everyday life but if we look for them we find that they are everywhere; in the repeated windows on the side of an office building, the rows of apples on a market stall, the pebbles on a beach, the shadows cast by railings on the pavement - the possibilities are endless.

⬆ *Unusual patterns and colours create interest.* ➡ *Reflections are useful in helping to create a sense of symmetry.*

Composition: **Natural Frames**

One reason why we put pictures into frames is that the frame separates the art from its surroundings and forms a boundary that helps keep the eye within the picture. It is another eye-corralling tactic. For centuries artists and photographers have found natural elements within their scene to provide a ready-made frame for their subject and help to prevent the eye from wandering out of the picture and losing interest. It is yet another device for holding the viewer's attention, and for creating harmony within the image.

Finding Natural Frames

The classic devices include shooting through open doorways (so that the door frame becomes a natural frame for whatever is visible though the door) as well as windows and archways (such as in a church or ruined castle). These are very literal interpretations of a frame, but one of the most common devices is to photograph a landscape from under a tree, so that the overhanging branches droop down into the top of the frame

⬆ *Natural frames are all around us.* ➡ *Frames create harmony within the image.*

from above. This gives the viewer a sense that they are peeking out into the landscape but, crucially, the branches help to prevent the eye from wandering out of the top of the frame. Placing the trunk of the tree down the left or right hand edge creates a frame to the side. Shooting through the boughs of a tree can create a v-shaped frame for a landmark in the middle distance.

When you are out with your camera look for interesting and unusual ways to frame your picture, such as shooting through a car window, or using people as a frame. Try shooting through a crowd, or through the 'window' created by a hand on a hip.

Framing People

Frames can also be used in portraiture. A bob haircut is among many hairstyles that provide a natural frame for the face – use things like this to your advantage. If the model is confident try placing their hands and arms in such a way that they frame the face, either in a self-consciously stylized way or, if the subject is less used to posing, in a more subtle and natural position which, nevertheless, still forms a frame.

⬆ *This car windscreen has become an unusual but highly effective frame.* ➡ *Frames direct the viewer's attention towards the subject.*

Composition: **Viewpoint**

More than 90 per cent of photographs are taken from between 1.5-1.8 meters (5-6 feet) above the ground. This is the height of the average adult's eyes. Very few people think to stoop down low or find a higher vantage point, and yet those who do are often rewarded with more visually striking and unusual results.

Shooting from Heights

The most obvious reason for seeking a high viewpoint is to get a better view – perhaps to see over a crowd. While this is a valid reason, and is a much better strategy, on the whole, than trying to shoot through the crowd, it is not always necessary. High viewpoints provide a better view of distant landscapes, and let you see more detail in the middle distance. Try climbing a tree, a hill or even just stand on a wall or park bench. In the city head for the top of a tall building to get a sweeping uninterrupted vista of the metropolis, or find an open window halfway up to photograph an adjacent tall building (such as a church) without having to tilt the camera upwards (which makes the sides appear to converge as if the building is falling over). Taking a high viewpoint to photograph children or animals is not generally

⬆ *Detail lost on the ground is captured here.* ➡ *A high viewpoint can change your perception of the subject.*

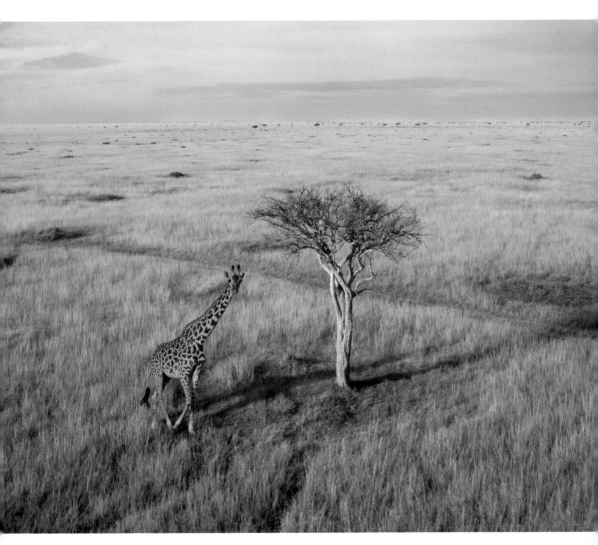

recommended as standard practice but does serve to emphasize their smallness and can add humour if used sparingly.

Shooting from Low Down

There are times when it is better to bend the knees and shoot from a low viewpoint. In general you'll get better results photographing children if you crouch down to their level and look them in the eye, as if you are entering their world. The same applies to pets. Getting down low means you won't get a distorted view of them (such views can give your subjects a disproportionately large head) and is much more flattering.

Subjects at Ground Level

Landscapes, too, can be shot from ground level to emphasize the foreground. You may wish to draw attention to some flowers, or show the texture of sand, stone or cracked earth receding into the distance or perhaps you want to use a line such as a path or road marking to pull the viewer in from the foreground to the horizon. If you want that emphasized foreground to be sharp it is best to use a wideangle lens. To get a blurred foreground you will get better results using a longer focal length lens.

Many digital cameras offer an LCD screen that can tilt and swivel, making high and low-level photography much easier.

⬆ *Stooping low can improve composition.* ⮕ *Remembering to look up can result in fantastic, unusual images.*

Composition: **Shape & Orientation**

Just as few people think to select a higher or lower viewpoint before taking a picture, most amateur photographers keep the camera in the horizontal position for all their pictures, irrespective of the shape of the subject, and they do not think to rotate the camera 90 degrees to see if that improves the composition. There is some confusing terminology in photography whereby a horizontally oriented image is known as 'landscape format' and a vertically oriented image is called 'portrait format' – irrespective of the subject.

Getting the Orientation Right

This terminology applies to both the camera position and the orientation of prints, but the terms are misleading. Firstly, there is no rule that landscapes should be taken horizontally and portraits vertically. Indeed there are thousands of examples of great vertical landscapes and horizontal portraits. Do take a good look at your subject before shooting to see whether or not the shot would look better if you turned the camera. Many professional photographers shoot their subjects both ways, as it gives the client more choices in designing the layout of the page on which the photograph will be used.

⬆ ➡ Portrait images can offer a new perspective, while landscape images are a popular option.

Trying Something Different

Sometimes you may, for aesthetic reasons, eschew both orientations and go for a square image. Many professional medium format cameras produce square images straight out of the camera and photographers such as David Bailey are known for their square portraits of personalities such as the Kray twins. No current consumer digital camera produces square images but photographs can be cropped, if the subject looks best that way, and square picture frames are widely available.

Alternatively you can go to the other extreme and create a long, narrow letterbox-shaped image – either in the horizontal or vertical orientation. This type of image, known as a panorama, is achieved either by cropping the top and/or bottom (or sides) off a normal picture, or by shooting two or more pictures of adjoining parts of the scene and then 'stitching' them together to form a seamless whole.

Importance of the Subject

In conclusion, no one is forcing you to stick with a 5:4 ratio, horizontally shaped picture if it does not suit the subject. Don't be afraid to turn the camera or change the shape of the image altogether later on.

⬆ ➡ *Landscapes often suit the subject, but turning the camera offers a different focal point.*

Composition: **Wideangle Perspective**

The standard lens on a digital camera is so called because the view of the world that it produces is roughly equivalent to that seen by the human eye. In other words a subject at a given distance appears to be roughly the same relative size and distance away as it does when you look at it with the naked eye.

Limitations of a Regular Lens

This is fine for some things but sometimes you can't bring everything into the shot and you can't stand back far enough. This is a particular problem with big groups and small interiors. Conversely, sometimes you just can't get close enough to your subject, either because you are at a sports venue such as a Grand Prix or football match, or because your subject is shy or dangerous, as with much wildlife.

Lens Options

Luckily, by changing the arrangement of lens elements within the lens, optical scientists have created wideangle lenses (which make things look further away) and telephotos (which appear to

⬆ *Wideangle works well with low angles.* ➡ *A wideangle shot makes a striking photograph.*

bring them closer) and most cameras nowadays come with a zoom lens that is slightly wideangle at one end and telephoto at the other. These lenses, by dint of where they make you stand, produce an optical side effect that can be put to good compositional effect.

Using a Wideangle Lens

Shooting from close with a wideangle lens creates the illusion of exaggerated perspective so that subjects up close to the camera appear much larger than those further away. By being close to a foreground area you can give this much greater prominence in the image. This works very well with low angles. Want to add a strong

leading line cutting diagonally through the image? Use a wideangle and get closer to it to make it really jump out at you.

Being close to a portrait subject or candid street scene provides a sense of immediacy to the viewer. Photojournalists often favour wideangles for the sense of drama they can give to a scene. The wider the angle of the lens (i.e. the shorter its focal length in mm), the more exaggerated the effect. However, if a lens has too wide an angle the field of view begins to distort. Straight lines begin to turn into curves until, at their logical conclusion, wideangles become fisheye and everything (including the shape of the image itself) becomes circular. These lenses can be good fun but should be used sparingly – their useful applications are quite limited.

⬆ ➡ *Wideangle lenses are great for capturing large structures, giving them greater prominence.*

Composition: **Telephoto Perspective**

Telephotos have the opposite effect to wideangles. When used from afar they compress perspective, making objects, are in reality quite far apart appear to be almost on top of one another. Distant hills or other elements in a landscape are apparently 'brought closer' and made more prominent in the image.

Tricks of the Telephoto Lens

Cars on a racetrack seem inches apart when viewed head on (not side by side) when in reality they may be some distance apart. The telephoto trick is used in movies to good effect. In a scene where someone may be running down a railway track towards the camera with a train coming up behind them, the use of a long telephoto lens will imply that the person is about to be run over when in reality there may be more than 50 metres (164 feet) between them.

Telephoto Effects

With telephoto lenses perspective is flattened and appears more two dimensional, which also helps to emphasize natural patterns and tonal contrasts

⬆ ➡ *Telephoto lenses are great for candid shots, but they can also provide a more detached view.*

within a scene. Portraits and street scenes take on a different tone. Far from getting a sense of being in the middle of the scene, as the viewer is made to feel with wideangle lenses, the viewer now becomes a voyeur, distant and more detached from the emotion of the moment. This is not necessarily a bad thing. It all depends on what you are trying to convey. Telephotos are also good for getting natural candid shots of your children, since you can observe them in their own little world without intruding into it, disturbing them and ruining any chance for a spontaneous and unselfconscious moment.

Telephoto Drawbacks

One side effect of telephotos is their reduced depth of field. The zone of sharp focus seems narrower so your focusing needs to be more precise with a telephoto than with wideangles. With telephotos, you cannot get away with manually setting the lens to a

point such as 2 metres (6 1⁄2 feet), stopping the lens down to f/8 and leaving it there, in the knowledge that everything in the frame will be in focus. However, the narrow focus effect of telephotos can be helpful, especially with portraits, because it makes it easier to throw any distracting background detail out of focus and really concentrate the attention on the face of your subject.

⬆ *Make sure your focusing is precise.* ➡ *Natural patterns can appear emphasized.*

Composition: **Use of Colour**

So far we have concentrated on using shapes, lines and perspective as composition aids, but one image component that has a huge impact on the viewer is the colour contained within a scene. The very best colour photographs are those which use colour not simply incidentally, but are composed around the colours themselves. They are essays in colour. Therefore it is worth taking time to understand how colour applies to photography.

Colour Palette Composition

The colour palette is divided into three primary colours: red, green and blue. By varying the proportions of these three colours every other colour in the spectrum can be produced. Most digital camera sensors are composed entirely of blocks of red-, green- and blue-filtered pixels.

Complementary Use

Each primary colour has a secondary or complementary colour, made up by combining the other two primaries. The complementary of red, therefore, is cyan (a type of turquoise) as it's made up of green and blue. Green's complementary colour is magenta (bright pink) made from red and blue, and blue's complement is yellow, which is what you get when you mix red and green light. Images that cleverly use a primary colour with its secondary colour often look good. But as with all ideas, don't over-use this concept. In general scenes that contain all the primaries may clash, but there will be occasions

➡ *Vivid colours result in striking images.*

where they look good together – such as in a stained glass window. It all depends on the context in which they are being used. It is the photographer's job to make sense of colours and, by careful use of composition, create something interesting out of them. This could take the form of a repeating pattern or random abstract.

Isolating Colours

One technique that often works well is to isolate a single colour, such as red or yellow, so that this is the only strong colour in the scene. Think of a frame-filling detail from a red London bus, or perhaps a field of vivid yellow rapeseed, which looks good not only against a blue sky (its complementary colour) but with the sky cropped out, and perhaps

a lone figure walking through it. Landscapes are often essays in different shades of green. With some thought it is possible to build a collection of photographs on a single colour theme, and when you put them all together they make a great-looking set.

The Colour of Light

One final point to consider is the colour of light. An object can appear to change colour according to the hue of the light falling upon it. A banana will not look yellow if it is lit entirely by red light. Brightly coloured lights are extremely photogenic – think of dusk and night photos of cities, with their neon and other multi-coloured lights.

⬆ *Colour combines with patterns to great effect.* ➡ *Careful composition will highlight intense colours.*

Composition: **Seeing in Black & White**

Once upon a time all photography was black and white. Early films could only record the intensity of light, not its colour. Colour photography was invented early in the twentieth century but it took another 50 years for colour to be good enough and cheap enough to gain mass popularity.

The Persistence of Black & White

Digital has been colour from the outset, but despite all the advances in colour technology (for example developments of new colour dyes and pigments for printers,

and improvements in the way colour is reproduced in cameras and on PC monitors), black and white photography will not go away. There is something special about black and white photography – also known as 'monochrome', 'mono' or just plain 'b&w'. It has the ability to get to the heart and soul of a subject without the distraction of colour. It isn't superior to colour, but neither is it inferior. Whether you choose colour or black and white depends on what suits the subject and what you are trying to say.

Although you can shoot in colour and convert your pictures to mono later you may wish to set the camera to its black and white mode, especially if you don't have a PC or you wish to print directly from your camera.

⬆ *Black and white is ideal for capturing textures.* ➡ *Unusual subjects are brought to life in this medium.*

Visualizing Black & White Scenes

Either way, to achieve successful black and white images you must first learn to see the world in a different way. You need to visualize a scene without its colour in order to assess how it may look as a black and white print. For example, scenes that rely on colour for their impact, such as a carnival or fairground, are unlikely to succeed in mono. Some colours that look different in the real world may reproduce as the same tone in black and white. For example, the three primary colours (red, green and blue) may all reproduce in black and white as the same shade of grey.

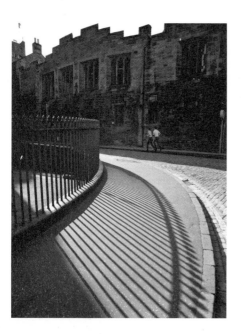

Subjects for Black & White

Subjects that work best in mono are those that explore shapes, tones and textures, and the interplay of light and shadow. Portraiture also works very well in mono, and can be more flattering than colour, because blotchy skin, spots and ruddy cheeks can be made less obvious or even made to disappear.

Black and white film users have traditionally used colour filters over the lens to control the relative tones of the colours on the film. For example, a red or orange filter darkens a blue sky. This is unnecessary in digital because the individual colour channels can be independently adjusted later, on the PC.

⬆ *Patterns, light and shadow work together here.* ➡ *The moody feel of this shot would be lost in colour.*

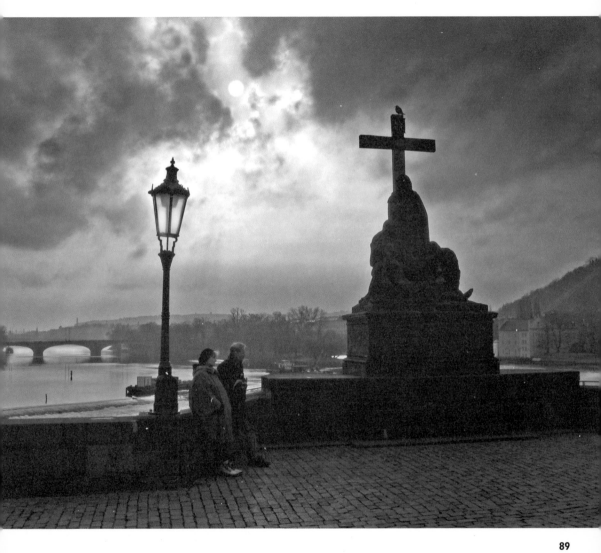

Focusing: **Modes**

Probably the worst technical mistake you can make is for your picture to be out of focus – which is why modern digital cameras are stacked with technology to help to ensure that this doesn't happen. Most of the time it works, but occasionally it doesn't. With a little knowledge, the failure rate can be reduced to almost zero.

Automatic Focusing

These days we take automatic focusing (AF) for granted but the technology is quite recent. There are two types of AF. Simple budget cameras use 'active AF' in which an infrared beam is fired at the subject to measure the distance and then the camera sets the lens to focus at that distance. Simple cameras can only focus on a limited number of distance zones, and the camera sets the one closest to the measured distance. Sophisticated cameras have more zones, or can focus on any point from about 30 cm (12 inches) or closer to infinity. These also tend to use 'passive AF' to achieve focus, wherein the camera examines subject edges within the image and adjusts the lens to make them as sharply defined as possible.

Focusing on the Subject

In both cases the camera has to guess which of the many elements in your picture constitutes your main subject. It generally assumes that it is the closest and most central object in the frame and focuses on that, and nine times out of ten it is correct. Simple cameras measure distance from the centre of the frame, so if your subject is off-centre

➡ *The closest object is usually assumed to be the main subject.*

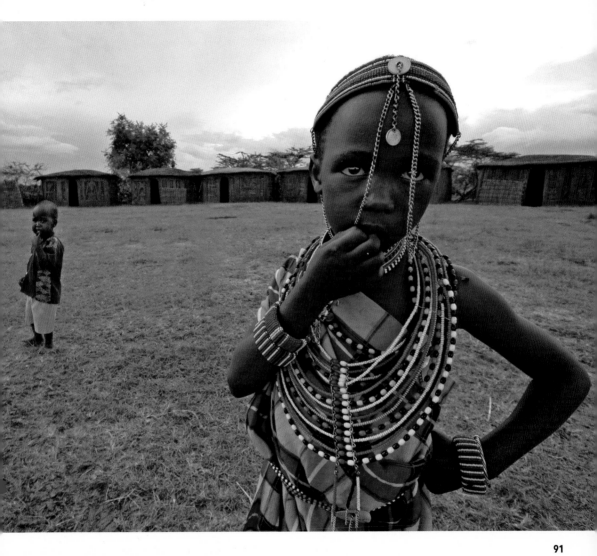

the camera my look past it and focus on some more distant object. One way to avoid this is to use the focus lock, which almost all cameras have. This involves pointing the central point at your subject, pressing halfway down on the shutter button and holding it there, then repositioning the camera before taking a picture.

Some more advanced cameras avoid the need for this by employing several focus points dotted around the frame – in fact several dozen, in the case of some Single Lens Reflex cameras (SLRs). These measure the distances of all the elements in the frame, and complex algorithms then work out which one is the subject. It is also usually possible to manually select between the various focus points if you feel the camera needs some help. If an off-centre subject has much higher contrast than a central one, the system may be fooled.

Capturing Motion

All cameras use, by default, a 'single shot' focus method, where once the camera has locked on to the subject and focused, it will stay at that point until you either take the shot or let go of the shutter button. This is fine for static subjects but for moving subjects most cameras offer a 'continuous AF' mode, whereby the camera keeps refocusing as long as your finger is half-depressing the shutter, and you can fire at any time, whether the subject is in focus or not.

⬆ *Today's cameras can shoot even distant subjects in perfect focus.* ➡ *Moving subjects can be shot in focus in 'continuous AF' mode.*

Depth of Field Techniques

To exert maximum creative control over the visual appearance of your picture, it is essential that it is you who is telling the camera what to focus on, not the camera telling you. This may mean using the focus lock, or changing the focus mode, or perhaps leaving the comfort zone of AF altogether in favour of manual focusing. This is more difficult with compacts, but some models enlarge the central portion of the LCD to aid accuracy. With SLRs, of course, manual focusing is simple and straightforward - just a bit slower than AF.

What to Keep in Focus

However, creative control is not just about the point of focus, it is also about the depth of the zone of focus. In other words, how much of the scene in front of and behind the main subject do you wish to be sharp? The answer may well be 'all of it', especially in the case of landscapes, where you may want everything from the foreground flower to the horizon crisply sharp. But with a portrait, for example, do you really want to see the background sharp enough to distract from the main subject? This zone of focus is known as the depth of field, and deciding how much you want is one of the most important

⬆ *You may not want the background to be in focus in a portrait.* ➡ *A shallow depth of field allows you to focus on the foreground.*

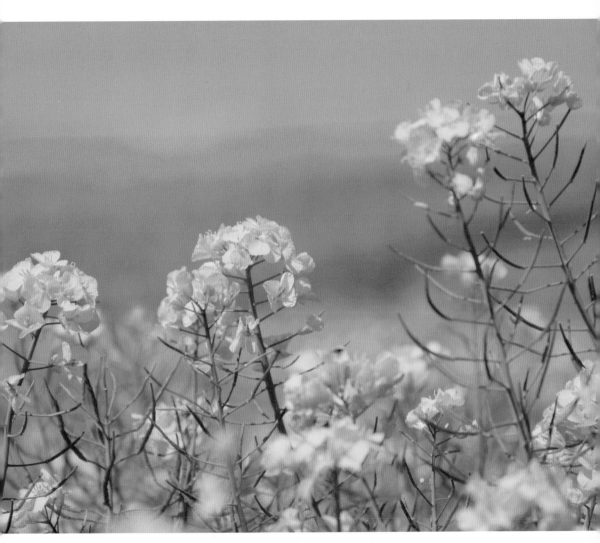

creative decisions you will make. A shallow depth of field is ideal for making your subject stand out from its surroundings, such as for drawing attention to a single flower in a field, or a single face in a crowd.

Aperture Variations

The depth of field is controlled by the size of the lens aperture. The smaller the aperture (i.e. the higher the number) the more depth of field you will get. The wider the aperture, the shallower your depth of field will be. Depth of field extends both in front of and beyond the point focused on, in the ratio of one third in front and two thirds behind for distant subjects and half and half when you are very close to a subject. The exact amount

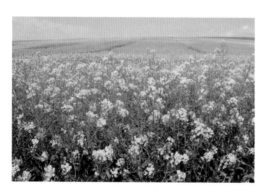

of depth of field you will achieve depends on several variables in addition to the relative size of the aperture.

Lens Variations

Larger image magnifications reduce the depth of field, while smaller image magnifications increase the depth of field. So longer focal length lenses (i.e. telephotos) provide less depth of field at a given aperture, while wideangles provide much more. Equally, the closer you are to your subject the less your depth of field will be, so at a given aperture your depth of field will be much shallower at 15 cm (6 in) than 2 m (6 ft). Therefore a wideangle lens at a small aperture focused far away gives you maximum depth of field, while using a telephoto at a wide aperture close-up will provide the shallowest.

⬆ Both the foreground and the horizon are in focus using a small aperture. *➡ You can also focus on the middle distance.*

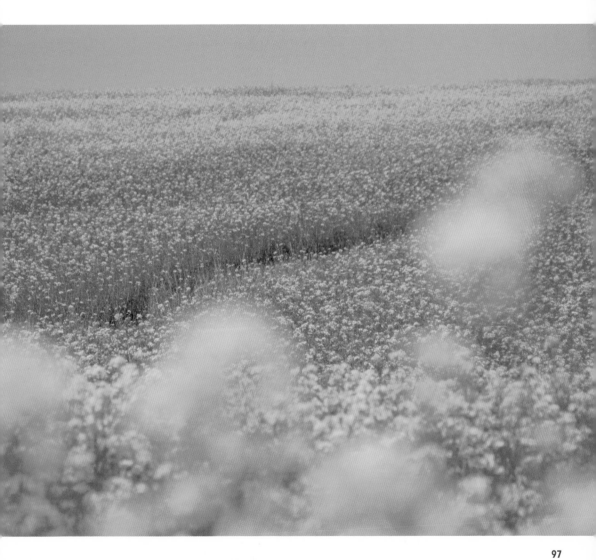

Exposure Modes

Left to their own devices, cameras measure the light and set the exposure without any intervention from the photographer. All but the most basic models offer a variety of exposure modes, each of which employs different criteria in deciding which of the various settings to select. Some are fully automatic, others require some input from the photographer. Here is a brief rundown of the main modes:

Auto Mode

In the auto mode (usually marked in green) the camera takes care of everything. Not only are you not required to make any decisions, in most cases you are prevented from doing so. This is an ideal mode for novices, and most of the time the results will be fine.

Program Mode

The camera still does everything, but it does offer you some degree of override. For example, it is usually possible to apply exposure compensation (subtly increasing or decreasing the exposure an image receives), alter the shutter speed/aperture combination using program shift (which still keeps the overall value the same) or switch the flash on and off.

Shutter Priority

This is a semi-automatic mode, in which you have to choose which shutter speed to use, and the camera then matches it with the corresponding aperture that will provide the right exposure in the prevailing conditions. This mode is ideal when photographing moving subjects. You can choose a fast shutter speed to freeze the movement, or a slow

➡ *Shutter priority allows you to capture motion.*

one to blur it. Please note that you need to check that the selected shutter speed is able to deliver a correct exposure with the available aperture range.

Aperture Priority

In this mode you select the desired aperture and the camera sets the necessary shutter speed. So if you want a shallow depth of field, pick a wide aperture and the camera will set a fast shutter speed. As you stop down the aperture to get more depth of field, the shutter speed will automatically increase in duration to compensate. Please note that you need to ensure that the camera can set a shutter speed within its range given the aperture you have selected.

Manual Mode

In this mode you set both the aperture and shutter speed, based on information provided by the exposure meter. This mode is useful for shooting panoramas, when you want every exposure in a sequence to be the same, and do not wish any frames to be influenced by any dark or light bits in the scene. Studio photography is another situation where manual is best. The meter will still show its recommendation; you need to decide whether to ignore it or not.

Scene Modes

Sometimes called subject modes, these are a selection of pre-set modes covering a variety of types of subject. Common examples are landscape, portrait, sport and night modes, but you can also get special modes for beaches, skiing, parties, text, etc.

In each mode the parameters are optimized for the subject. This may include things such as the ISO and white balance, as well as the shutter speed and aperture.

↑ *Many cameras have a pre-set 'beach' mode.*　➡ *A landscape mode would be ideal here.*

Photographing Motion

The aperture controls the intensity of the light reaching the sensor, and the shutter speed determines the duration of the exposure.

In fact, it does more than that, because, just as the aperture affects depth of field, so the choice of shutter speed can have a profound effect not only upon how the subject is recorded, especially if that subject is moving, but also on whether the movement of the photographer results in the image being ruined by the effects of camera shake.

Shutter Speed

Most SLR shutters are of the focal plane type, which means that they are comprised of two vertical or horizontal blinds. The first one opens to expose the sensor, then the second one closes behind it to end the exposure. The time delay between these curtains determines the shutter speed. At high speeds, the second curtain must actually start to close before the first one has completed its journey, creating a moving slit which travels across the frame; the faster the speed, the narrower the slit. This has an effect when using flash (see pages 114–117).

Capturing Movement

With moving subjects, the longer the shutter is open, the more the subject will have moved across the frame during the exposure, creating a blur as it does so. At fast speeds,

➡ *Experimenting with the aperture and shutter speed can produce exciting results.*

the narrow slit moves so quickly that only a fast-moving subject will have time to move across the width of that slit before it is moved on to expose the next band of the scene.

Therefore, if you want to record a moving subject in sharp focus, you need to set a fast shutter speed – and the faster the motion, the faster the shutter speed needs to be. However, you may not always want to 'freeze' the motion. With some subjects, such as racing cars, the target can look stationary rather than 'frozen in time', thereby destroying any sense of motion and dynamism. Sometimes it is best to deliberately allow the moving subject to record as a blur, by a controlled amount, to show that it was moving. In these situations a slower speed will be required. There is a third option – by using a

slower speed, but moving the camera in time with the subject so it stays at the same point in the frame, the subject will remain relatively sharp but the background will be blurred by a streaking motion. This technique is known as panning.

Trial and Error

It's difficult to suggest specific shutter speeds for specific moving subjects because there are so many variables, including the speed and direction of travel, distance from the lens, and of course the degree of blur or sharpness required. The big advantage of digital is the ability to experiment and see the results immediately, so it won't take long to ascertain the optimum speed in a given situation, simply by trying a few of them out and reviewing the results.

⬆ *A fast shutter speed freezes a moving object.* ➡ *Animals in flight can be captured cleanly.*

Light

The word photography comes from two Greek words, and means drawing with light. It is the perfect name for the medium, because photography is all about light. Without it there would be no photographs, but it is not enough for there merely to be a sufficient quantity of light to take a picture. Photographers talk about the quality of light, and this is much more important than the quantity.

The quality of light is a combination of the size, distance, direction and colour of the light. These various qualities guarantee an almost infinite combination of lighting effects, which, in the case of natural light, are constantly changing. The human eye barely notices these effects, but the skilled photographer must learn to understand and manipulate them.

Hard and Soft Light

The size of a light source has perhaps the strongest influence on the quality of illumination. The smaller the source, the 'harder' or higher contrast the light falling on the subject will be – it becomes an intense, brightly lit area surrounded by very deep

⬆ *Shadows and bright light can combine to great effect.* ➡ *Soft afternoon light can make a beautiful photo.*

shadows. The distance is another determining factor. As a light source moves further away it becomes smaller, and therefore harder in quality.

One way to make the light source larger is to diffuse it. Outdoors this is achieved by clouds. On an overcast day the sun is hidden by cloud, so the entire sky becomes one big, soft light source. The illumination it creates is virtually shadow-less. In the studio photographers use all sorts of devices to modify their lights to achieve a similar effect, such as softboxes (light translucent tents fitted over the lights through which the light is fired) or umbrellas (white or silver to bounce the light back on to the subject).

Light Direction

As well as the size and hardness of the light photographers must pay attention to its direction. For even, frontal illumination there's a rule that says photographers should keep the light source (sun or otherwise) behind them, so it lights the part of the subject that is facing the camera. While there is nothing wrong with that, the result can look a little boring creatively, and sometimes it is more interesting (yet also more challenging) when it is coming from elsewhere.

Colour Temperature

The final factor that determines light quality is its colour (technically known as its colour temperature, as it is defined in degrees Kelvin with relation to the light emitted by a notional perfectly black body heated to that temperature). Daylight is constantly changing in colour, though we rarely notice it. First thing in the morning, and again at dusk, it is at its warmest (i.e. its most yellow-orange). At midday it is bluest. Atmospheric conditions affect things too – a cloudless blue sky produces a bluer light on the ground, for example, than direct sun.

➡ *Daylight is often 'cooler' in temperature during winter.*

Artificial light is a completely different colour. Traditional tungsten filament light bulbs produce a very orange light compared with daylight, and fluorescent tubes can often add a greenish tinge that is rarely attractive.

Digital cameras control this light colour with a function called the 'white balance', and with most cameras it adjusts automatically (just as our eyes do). Most cameras also offer a range of manual presets for when the auto setting is wrong, or for when you wish to override the camera's choice.

The Right Light

There is no right or wrong type of light – only what is right or wrong for a given subject. Landscapes, for example, are often at their most alluring when the light is low, hard and from the side, or you are shooting into it. The long shadows this creates add shape and contour to the land. Beauty portraits are almost always lit by soft, shadowless light, as harder light will emphasize any wrinkles or blemishes in the skin.

ISO Sensitivity

Photographers often talk about there being enough light to take a picture. This means sufficient brightness to take a picture without the risk of camera shake – that blurring of the image caused by our natural and unavoidable body movement during the exposure.

At higher shutter speeds this movement is not noticeable in the picture, though the threshold depends on many

⬆ *'Harder' light can also result in an impressive picture.* ➡ *A blurred effect in low light can sometimes make for a great picture.*

factors, including the steadiness of the individual and the choice of lens – the greater the zoom magnification the higher the speed needs to be to avoid shake. Generally, with a lens at the standard (non-zoomed) position, the minimum safe shutter speed is around 1/60 sec, but this rises significantly as you zoom. Some people are also more prone to shaking than others, and it's worth doing some tests to see what your safe shutter speed is.

That works when there is enough light for the camera to set that speed (and with program modes it will always try to) but what happens when the light fails? Or what if you need to use an even faster shutter speed to capture a moving subject, which pushes the shutter speed below that threshold? Automatic cameras will turn on the flash, which you may not want, and which doesn't work with distant subjects anyway. Another option is the tripod. The last option is to increase the ISO rating.

Adjusting the ISO

In the days of film the ISO (formerly called ASA) was a measurement of the sensitivity of film (i.e. how much light was required to record an image). Film came in different sensitivities, but the faster (more sensitive) the film, the more grainy it was. The sensors of digital cameras work in a similar way. In most cameras, the default sensitivity is ISO 100. You can raise the sensitivity of the sensor to at least ISO 400 and often ISO 1600.

However, the higher the ISO, the more the image quality suffers. This is because in order to raise the sensitivity the camera amplifies the electrical signals from the sensor, and also therefore amplifies the 'noise' (non-signal impulses). Noise can take many forms, but often shows up as a blizzard of tiny, multi-coloured dots, most visible in dark areas and areas of continuous tone. It is intrusive and unattractive, destroys fine image detail and lowers contrast, so it is always best to use the lowest ISO setting that conditions will allow – even if that means using a tripod.

➡ *Use a high ISO setting to capture sharp images in low light.*

Flash

When the light level drops to a point where it is no longer safe to take a picture without risking camera shake, most cameras automatically switch on the flash. This is fine for emergencies, but unfortunately flash is not always the best solution – and the result is often disappointing photos.

How the Flash Works

Flash spreads out over distance, and only has a very limited effective range. Double the distance, and the intensity of the light hitting a given point drops by a factor of four. If not enough light reaches the subject, the resultant image will be underexposed. Built-in flashguns are usually very small, so you have only got a very small intensity to start with. The maximum range is 3-4 m (10–13 ft). Beyond this, flash is largely a waste of battery power. Increasing the ISO also increases the usable flash range – double the ISO setting and the flash range increases by a factor of 1.4. Switch from ISO 100 to ISO 400 and you double the range.

Within its specified range using a flash will give you a picture, but it may not be a flattering one. Direct flash is harsh and, when the background is dark, can lead to very washed out faces. It can also cause 'red eye'. In low light, our pupils open wide to let in as much light as possible, and flash entering the eye from the camera position illuminates the blood vessels on the retina and reflects back through the lens. Anti-red eye settings can reduce this problem, but it should be remembered they are red eye reduction, not red eye elimination, functions.

Cameras provide a selection of flash modes for the optimum result:

➡ *Flash has a limited range but eliminates camera shake.*

Auto

The camera does all the thinking. Fine for party pictures (except for the red eye), indoor gatherings etc.

Auto with Red Eye Reduction

This can reduce red eye, but the delay it causes between pressing the button and the picture taking often results in unnatural expressions and is generally more trouble than it is worth.

Slow Sync Flash

In auto flash mode the camera sets a shutter speed of 1/60 sec or faster, which reduces the dim available light to a sea of blackness. If you want to show something of the

environment in which you are shooting, slow sync flash combines the flash with a slow shutter speed to record the ambient light – though you will need to rest the camera on a stable surface and ask people to keep still to avoid blurring.

Flash Off

Sometimes flash is prohibited (such as in museums and public places) so you should set this mode to override the camera's natural instinct to turn it on. In this mode the camera sets a longer shutter speed, so you will need to find something stable to support it.

Flash On Fires the flash even though the camera does not think it is necessary.

⬆ *Flash is useless for subjects beyond about 4 metres.*　➡ *If shooting with flash off, you will need a steady hand.*

Landscapes

The rural landscape remains the greatest inspiration for hobbyist photographers. Luckily good subjects are all around us, and few of us live far from an area of natural beauty – whether farmland, woodland, lakes, mountains, deserts or coasts.

Best Time to Shoot

Most landscape photographers aim to capture an idealized view, free from cars, people, pylons and other examples of modern life. This is one reason why they rise before dawn to be at their location when it is at its most undisturbed. This is also usually when the light is at its best, and good light is the most important ingredient of a successful landscape photograph.

Weather Conditions

Landscapes can be photographed at any time of day though, as long as the light is good, and this does not necessarily mean sunshine. Fog, mist, rain and stormy skies are often more photogenic than bland summer sun. Obtaining the best light means studying it and waiting – minutes, hours, maybe even weeks or months – for that magic, fleeting moment.

Filling the Foreground

Composition is crucial. A distant view from a hilltop may look great when you are there, but pictures where all the points of interest are at the horizon rarely succeed. The best

➡ *Holidays offer a great opportunity for capturing unusual landscapes.*

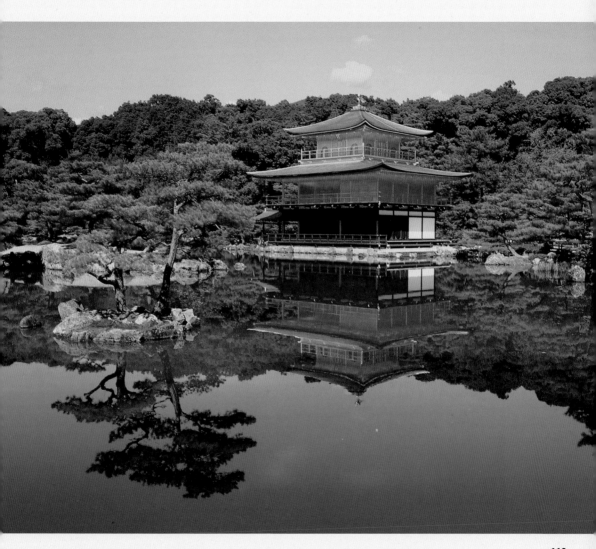

landscapes usually contain detail from foreground to horizon. Look for features such as gates, dry stone walls or flora to fill the void at the front of your picture.

With few exceptions, everything in the picture should be sharp, which means using a small aperture and focusing on a point in the middle distance to ensure crisp focus from foreground to horizon. In practice, this will probably mean using a tripod for stability at the slow shutter speeds.

Choosing the Lens

Landscape photographers often favour wideangle lenses – more of the scene is in shot, the foreground has greater emphasis (for a better sense of perspective) and there is greater apparent depth of field. However, good landscape photographers are also able to see and home in on interesting details within a scene, either close up or in the distance, perhaps using a telephoto lens to isolate them from their surroundings.

Top 5 Tips
➡ Wait for great light and, if possible, arrive at your destination very early.
➡ Frame the subject to include points of interest from foreground to background.
➡ Use a tripod and set the lens to a small aperture for maximum depth of field.
➡ Use wideangles for a more dramatic perspective, telephotos to isolate details.
➡ Revisit locations at different times of year to record the changes.

⬆ *Rural landscapes work particularly well.* ➡ *Clouds and natural features can be used to frame a landscape.*

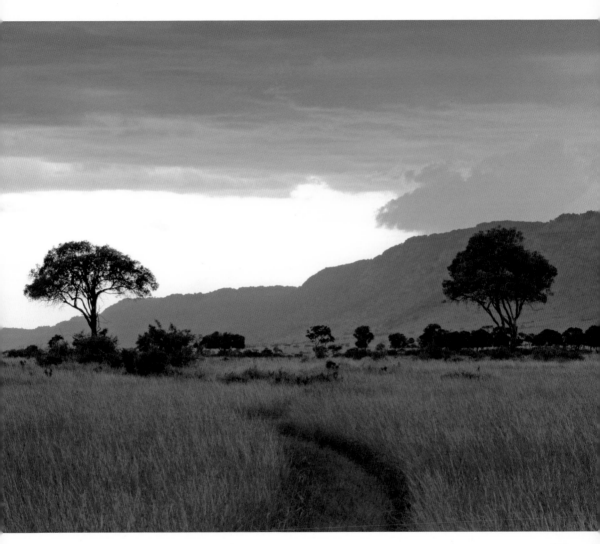

Sunrise & Sunset

Despite the cliché status of sunrises and sunsets, we never seem to get tired of them. They are nature at its most majestic, most magnificent. Taking good photographs of them, though, is not always so easy. This is partly because the automatic exposure and white balance functions of digital cameras conspire to eliminate just those qualities that make them so appealing in the first place, and partly because we are often so wrapped up in how lovely the sky looks that we fail to pay sufficient attention to what is going on in the foreground.

The Ideal Foreground

Clean, simple, uncluttered foregrounds work best. The most successful examples are those where the foreground makes an interesting and instantly recognizable silhouette. Bare winter trees, for example, or people can make very interesting foreground silhouettes. One of the best types of foreground is water: lakes, rivers, the sea – even a big puddle – because it reflects the beauty of the sky.

⬆ *Silhouetted buildings look very dramatic.* ➡ *A stunning sunset shot is well worth the wait.*

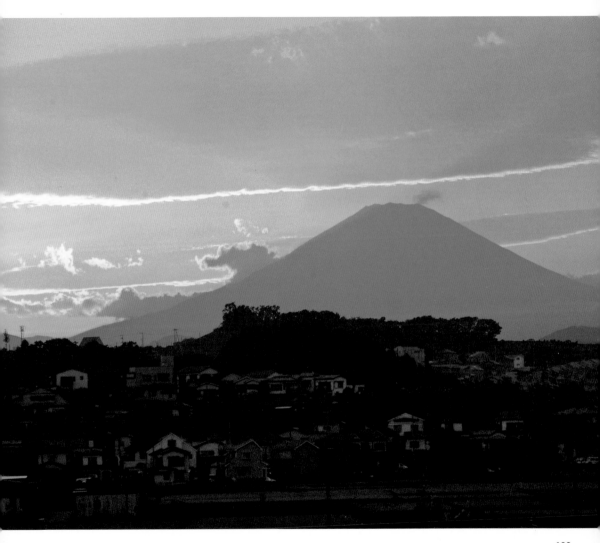

Choosing the Subject

Sunrise and sunset prop up either end of the day like bookends. It does not matter which you shoot – both can produce spectacular results. Sunrise has the advantage of being quieter, with fewer people and cars to spoil things, but you have to get up very early to catch it.

Technical Advice

Whichever you choose you should be at your selected spot well in advance. Use a tripod for stability. Your auto white balance will try to neutralize the colour and remove the orange hue, so turn off the auto and set it to daylight for maximum saturation – or for more control, shoot RAW files and sort out the colour balance later. You may find that auto-exposure produces unsatisfactory results too, as it tries to lighten your sky. Either take a manual reading from a bright part of the sky (but not the sun), or use exposure compensation of minus 1-2 stops. Once the sky reaches maximum saturation keep shooting until well after it has gone, especially at sunset when you can get some wonderful effects from the afterglow. Finally, bear in mind that the further north you go, the longer you have to shoot your sunset. The nearer the equator you are, the faster the sun goes down.

Top 5 Tips
➡ Choose an interesting foreground, such as water, or a recognizable silhouette.
➡ Get there early, and use a tripod.
➡ Set the white balance to daylight – not auto.
➡ Meter from the sky and check your exposures. Underexposure increases saturation.
➡ Take lots of pictures, and keep shooting until well after the sun has risen or set.

➡ *Dramatic skies with little foreground detail produce great photographs.*

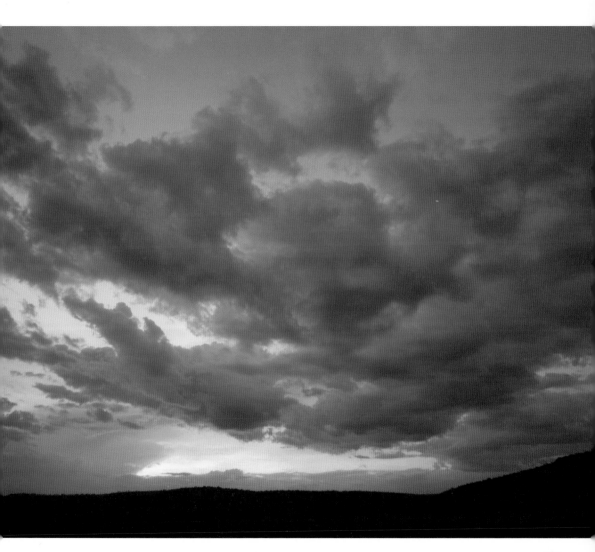

Sport & Action

We've all got pictures of half a car or part of a person just leaving the frame, as we tried to photograph them but were a split second too late pressing the shutter. It doesn't help that digital cameras in particular have a reputation for being slow to react to fast-moving situations. While this issue has now been largely solved on the newer cameras, even the swiftest cameras will let you down with fast action unless you adopt a few useful techniques.

Shooting Options and Technical Implications

There are two ways to shoot action: freeze the motion or introduce deliberate blur to convey the sense of speed. For family action shots the former is generally preferred so

you will need to select a fairly fast shutter speed, either via shutter priority mode, manual or sports mode. If you have selected a speed too fast for the prevailing conditions your camera should warn you, but review your efforts on the LCD to be sure. To introduce an element of deliberate blur you will need a slower speed (1/30 sec or below, depending on the type of action)

⬆ *Capturing movement can result in dramatic shots.* ➡ *The hustle and bustle of busy commuters is caught in this shot.*

and either allow the subject to blur itself as it moves, or follow the subject's motion with the camera to create a streaked background.

Whichever approach you prefer you still need the camera to fire at the right moment, and there are ways to maximize its responsiveness. Turn off the autofocus and pre-focus on a spot where you know the action will take place. If you can't turn it off, use the focus lock. Failing all that, at least set the camera to continuous AF mode, which lets you take a picture without having to lock focus first. Set the drive to continuous too, so that the camera will keep shooting as long as your finger is on the shutter.

Positioning

Pressing the shutter as you pan will minimize the risk of the subject leaving the frame before the shutter goes off. Alternatively, practise pressing the shutter just before the subject comes into the frame. If you position yourself so the motion is coming towards you rather than across your path, the illusion of speed is minimized, improving your chances of getting it both correctly framed and in focus. This technique is especially useful for motorsport photography. Remember that objects moving across the frame need a much faster shutter speed to freeze them than objects coming towards you.

Top 5 Tips

➡ Set a fast shutter speed to freeze action.

➡ Set a slower speed to add creative blur to convey movement.

➡ Set the camera to manual focus and pre-focus on where the action will occur.

➡ Select continuous drive mode and, if no manual focus, continuous AF.

➡ Position yourself so that fast-moving subjects are coming towards you.

➡ *A slower shutter speed blurs movement for an artistic effect.*

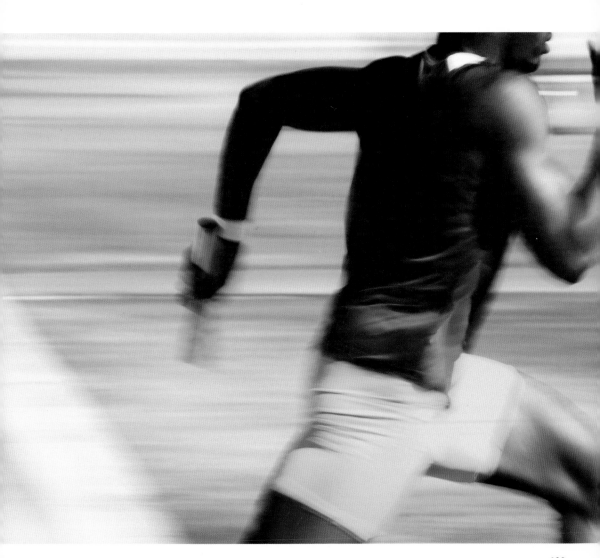

Posed Portraits

The difference between candid and posed portraits is that with one the photographer is reacting to situations, while with the other he has to create them. Creating a natural-looking portrait, especially with a model lacking in confidence, is no easy task. Posed portraits can be done outside or indoors, in a studio or a real room (home, office etc). Natural settings may make the model feel more at ease, whereas studios can seem intimidating.

Whatever the setting, three factors are crucial: lighting, pose and expression. For most portraits the light should ideally be diffused but directional. Placing your model near a window on a cloudy day is ideal. On a sunny day net curtains can help diffuse any harsh lighting. If the light is striking one side of the face, you may wish to use a white reflector to bounce light back into the dark side of the face to reduce the shadows. Some photographers seek to replicate the effects of soft window light using studio lighting, by fitting a white umbrella or softbox to create the same diffused look. Outdoors, direct sunshine produces harsh shadows and makes people squint, so look for shaded spots such as under a tree, against a north-facing wall, or indeed anywhere if it is cloudy. Use reflectors if necessary to direct the light, and perhaps create a highlight in the eyes (which is hugely desirable, because it makes them sparkle). Alternatively, on sunny days place the sun behind the model to create an attractive halo around the hair. You may need fill flash or a reflector to light the face.

Choosing a Pose

Find a natural pose that suits your model. Some people are comfortable standing, others look more comfortable sitting. Take care with hand placement as some people become

➡ *Capturing a highlight in the eyes really brings the photograph to life.*

self-conscious about them when being photographed. Give them something to do with their hands, such as holding a book, or resting their chin gently on a palm. Legs, too, can be problematic. If they are stretched out towards the camera, feet can appear oversized. If in doubt crop them out of shot.

Getting the Look

Finally, facial expression is vital, though this doesn't necessarily mean smiling. A natural smile is great, but a forced one is worse than no smile at all. Direct conversation to contrive good natural expressions, whether these be thoughtful, wistful or sexy. Be ready for fleeting expressions. Take lots of pictures to increase the chances of getting a good shot.

Composition

If photographing more than one person, place them close together with their heads at different heights and try to create an interesting compositional shape. Turning their bodies to face in towards each other creates a harmonious appearance.

Top 5 Tips
- ➡ Natural sittings, indoors or out, produce more natural portraits.
- ➡ Indoors, use natural window light, with reflectors to light the shadows.
- ➡ Outside, shoot in shade or with the sun behind the subject.
- ➡ Pose the subject in a position that looks natural and feels comfortable.
- ➡ Try to elicit natural expressions through direction. Don't ask for smiles on demand.

➡ *Most children love being photographed.*

Children

Making a record of your children's lives as they are growing up is something that both you and they will treasure when you are all much older.

With digital cameras there is no excuse for not being trigger happy, because it doesn't cost anything and you can delete the failures later. But don't just record the key events – the big family get-togethers – nor make them grimace into the camera with fake smiles. Instead, make an effort to capture those smaller, more intimate moments when they are playing in the garden or riding their bikes, or they are indoors doing arts and crafts. These are the moments you will remember and treasure. You can set up fun activities for the children with picture-taking in mind.

Facial Expression

In general, unposed shots with natural expressions that capture the children's personalities are far superior, and will bring back much more poignant memories, than posed shots. But there is nothing wrong with getting them to look into the camera if you can get genuine expressions – smiles or otherwise – out of them. Even the odd tantrum or sulking shot will raise a smile when viewed in later years.

⬆ *Get down to your child's level for the best shots.* ➡ *Try to record as much as you can of your children's lives.*

Technique and Positioning

Your best strategy when photographing children is to be always ready and react quickly to events. Close-range shooting with a wideangle lens will provide impact and a sense of intimacy. Pre-setting a camera to manual focus, a mid-range aperture and focal point of about 3 m (10 ft) will cut down the shutter lag and make picture-taking almost instantaneous. In low light set a high ISO rather than flash, which will remind them of your presence. When photographing children at close range it is generally best to get down to their level. This creates a more intimate image and gives the viewer a sense of entering the child's world, rather than being an outsider looking at the tops of their heads. That said, sometimes a shot looking directly down, with children looking up, can add humour or a sense of pathos to a situation.

With SLR cameras, or models with good zooms, an alternative strategy is to step well back with a long lens so they forget you're there, and observe, with your finger hovering on the shutter. Don't just go for full-length shots showing what they are doing – zoom right in and get some frame-filling head shots too.

Top 5 Tips

→ Take lots of pictures, all the time, and not just at special occasions.
→ Go for natural expressions, not forced smiles. Get some sad and grumpy shots too.
→ Pre-focus or set manual focus to cut the shutter delay and be always ready.
→ At close range stoop down to their level rather than looking down at them.
→ Try standing some distance away and shooting candids with a telephoto lens.

➡ *Be ready to capture spontaneous moments.*

Weddings

Few things are as intimidating to a photographer as being asked to photograph a wedding. The responsibility of capturing what is, to your clients, the most important day of their lives, can be overwhelming. Careful planning and organization will make it run smoothly.

Mix it Up

Firstly, talk to the couple to ascertain their needs. Find out the location, the number of guests, timings and the logistics of the day. Many young couples now prefer an informal fly-

on-the-wall approach to the traditional posed shots, but a good wedding shoot should be a mix of both styles. Older guests will expect a few group shots, and these are the only opportunities to make sure that you have a decent shot of everyone who was there, because it is easy to miss people when using the reportage approach. It is also advisable to have a few posed shots of the couple, but don't keep guests hanging around while you take them – keep it brief. Be loud, clear and decisive in your instructions so people know when they are needed.

Plan Ahead

Scout the venues beforehand to seek out potential locations for the posed shots, either outside the wedding venue or the

⬆ *Try to keep the posed shots as natural as possible.* ➡ *Interesting shots of the venue will break up the photos.*

reception. Go for places out of direct sun and with plain, but not ugly backgrounds. Make a list of the shots you need to get – exchanging the rings, cutting the cake etc. – and refer to it on the day. Find out if there are any restrictions on taking pictures during the ceremony. If you are allowed to shoot, be discreet, and don't use flash. Natural light looks better and is less obtrusive.

Equipment

Check your equipment before the day and make sure you have a spare camera and batteries. You can never have too many spare memory cards or batteries. Check all your settings before shooting, and refer to the histogram to ensure the exposures are good. Be careful with white dresses in sunshine, which can burn out and lose detail, especially when the groom is wearing a dark suit.

Afterwards back up the pictures immediately, for safety. Finally, if you are not the official photographer and are just taking some behind-the-scenes shots, try not to get in the way of the professional.

Top 5 Tips
➡ Talk to the couple beforehand to discuss their needs.
➡ Scout the venues beforehand to look for suitable locations for posed shots.
➡ Take a mix of posed groups and single shots plus natural candids.
➡ Work quickly and decisively. Don't delay people for too long.
➡ Take a spare camera. Check settings and results regularly. Back up immediately.

➡ *Look for interesting angles for the standard shots.*

Travel

Few genres are as rich in subject matter as other people's countries. There is something about visiting foreign, unfamiliar places that fires up the creative juices and lets us see potential pictures in things that locals may have long since failed to notice.

When we think of travel photography we usually picture images of the Eiffel Tower or the Taj Mahal. But, while it is unthinkable that we should not photograph these familiar wonders when we visit them, try to see them with fresh eyes, and seek out viewpoints and treatments that will put a refreshing new spin on them.

Try Something New

Most importantly, don't limit yourself to pictures of grand views and world icons. Travel photography is all about telling the story of the place – to convey a sense of the essence of the culture for those who have not been there. Try to capture little vignettes that encapsulate the spirit of the place you are visiting – perhaps the unusual foods displayed on a market stall, or a sign over a shop door. Look for the small details as well as the wide shots. Use the full range of your lenses to capture the wide spectrum of subjects.

⬆ *Even a market stall can make an exotic photograph.* ➡ *The most ordinary subjects can make fascinating, unusual images.*

A country is its people as well as its geographical features. Take some portraits of interesting locals. Nice, tightly cropped headshots of colourful characters are always effective but pay them the respect of asking them first, even if only in a non-verbal way – unless of course you are shooting candids and are able to work unobserved.

Equipment Tips

There are a few practical considerations too. Choose a gadget bag that you can carry on your flight as hand luggage. Never check your cameras in the hold. Pack plenty of spare media cards and spare batteries. Take a tripod, even if only a pocket one, so that you can take sunsets and night shots of spectacular views. If you have a lot of kit, pack a smaller day bag so that you can leave some of the heavy stuff at your hotel. Do not show off your gear but keep it discreetly in your bag or under a jacket when not in use.

Top 5 Tips

➡ Pack spare cards and batteries and take your gear as hand luggage.
➡ Try to find new and original approaches to familiar icons.
➡ Work to tell a story of the place in pictures, and convey its spirit and culture.
➡ Look for small details as well as general views.
➡ Photograph the people, if they don't mind, but desist if they object.

⬆ *Look out for unusual architecture.*　➡ *Good travel photography conveys the character of a place.*

Pets

Cats and dogs make great subjects for pictures. Cats have their famous aloofness, dogs their intrinsic comedic value – both make natural subjects.

Getting the Right Shot

Animals photograph well when captured head-on, looking directly into the camera. Zoom in tight to fill the frame for maximum impact, preferably at a wide aperture to throw the background out of focus. Don't be afraid to make a fool of yourself to attract the animal's attention.

Exposure Issues

Exposure can be a problem with some animals, especially those with dark or light fur. Dark fur can easily underexpose because it absorbs so much light. White fur in sunshine can burn out and lose all detail. Try overexposing by a stop with dark animals and underexposing with brightly lit white ones, but check the histogram on the camera to make sure.

Top 5 Tips
➡ Always keep a camera ready for any great pet moments at home. Be patient.
➡ For portraits, fill the frame. Attract their attention with a toy or by making noises.
➡ Try using a ball, toy or food treat to catch their attention and direct their gaze.
➡ Visit a farm park to get good close ups or environmental shots of farm animals.
➡ Increase the metered exposure for dark-furred animals, decrease it for white fur.

➡ *Do whatever you can to attract and hold your pet's attention.*

Wildlife

In addition to the obvious photographic skills, successful wildlife photographers need an encyclopedic knowledge of the subject, and lots of patience. First, rather than wandering aimlessly in the forest snapping anything that comes along, choose a subject that you wish to photograph and seek it out. It helps if it lives in an area local to you, because you can spend more time on your quest and get to know your subject better. Next, read up on the behavioural habits of your subject: where it lives, what it eats, when it comes out to feed and so forth.

The Approach Options

Most wildlife is shy and there are two approaches to getting close to it: stalking or finding a spot and lying in wait. Learning to quietly creep up on your subject without it noticing is a skill that must be learned through practice. Equally, many wildlife photographers spend not just hours but days sitting silently in a hide – a small camouflaged den made of wood, canvas or other material in which the photographer waits, with small holes for the lens to protrude from. If all this sounds like too much commitment there are easier ways. Stick with common, accessible subjects such as squirrels or birds. You can attract wildlife to your garden by planting the right shrubs or putting out appropriate food.

If your taste is for more exotic wildlife, such as big cats, then you have two options: go on a wildlife safari (there are some tailored especially for photographers) or visit the zoo or safari park. You can get surprisingly good shots in these places, if you compose carefully to avoid including cages, cars and crowds in the shot.

➡ *Capturing wild animals on camera requires great patience.*

Equipment Needs

Whichever approach you take, there are certain equipment needs common to almost all wildlife photography, the most important of which is a long telephoto lens. Some photographers prefer zooms, for their versatility, others favour fixed focal length lenses for their faster maximum apertures. Either way, whether you are shooting in your garden, at the zoo or on the Serengeti, you are likely to need lenses of at least 200 mm (equivalent) and maybe up to 600 mm. Shorter lenses can be used for environmental shots, where the animal is a small part of a wider view showing the setting. These shots provide context, but you will still want the close-ups. A sturdy tripod is also essential when using big lenses.

Top 5 Tips
➡ Study your subject. Find out where it lives, what it eats etc.
➡ Stick with local subjects to start with – they are more accessible.
➡ Try attracting wildlife to your garden, and shooting from the house.
➡ Practise in zoos and wildlife parks. Crop tightly to exclude giveaway details.
➡ Make sure you have at least one decent zoom/telephoto in the 200–400 mm range.

⬆ *A wildlife safari will ensure you get some great photos.* ➡ *A zoom or telephoto lens is well worth investing in.*

Nature

Although wildlife and rural landscapes could be considered nature subjects, the term usually refers to the photography of plants, flowers and trees, and the butterflies, bees and small creatures that live off of them.

Nature photography is generally conducted in situ, and with an ethic that involves leaving your subjects the way you found them – undisturbed and unmolested. In some situations subjects can be removed with a clear conscience and taken to a studio environment (fallen leaves, for example).

Optimum Lighting

The ideal light for most close-range nature photography is soft, overcast light, which creates virtually shadowless illumination. Bright sun can cast harsh and distracting shadows on the subject, which makes it difficult to see fine detail and reduces colour saturation. In some situations a strong sidelight or backlight can add an element of atmosphere, creating (in the case of backlighting, for example) an attractive halo around the subject.

⬆ *Look for bright colours and interesting shapes.* ➡ *Insect close-ups can make stunning photographs.*

Getting a Stable Shot

When photographing subjects such as flowers close up, use a tripod for stability and make sure the background is blurred so as not to cause a distraction. You may find it easier to get further back and zoom in using a longer telephoto lens to achieve this. If you are at or near ground level a small beanbag may be easier to use than a tripod.

Manipulating the Light

To enhance the light you can use creased foil or white paper as small reflectors. Occasionally, fill-in flash can be useful, in small doses. Commercially made reflectors fold up very small but can open up to provide useful fill light as well as a shield to stop the wind blowing your subject around – and therefore in and out of focus. Another trick is to use a thin piece of stiff wire behind the stem (out of camera shot) as a splint, to help keep the plant steady.

Top 5 Tips

➡ Soft, overcast light is generally most flattering.
➡ Low sidelight or backlight can help to create a sense of atmosphere.
➡ Use a tripod or beanbag for stability.
➡ Set a wide aperture - perhaps combined with a long lens - to blur the background.
➡ Use reflectors (bought or homemade) to modify the light and create a windbreak.

⬆ *Catching the right light can make all the difference.* ➡ *Quick responses are required when photographing natural subjects.*

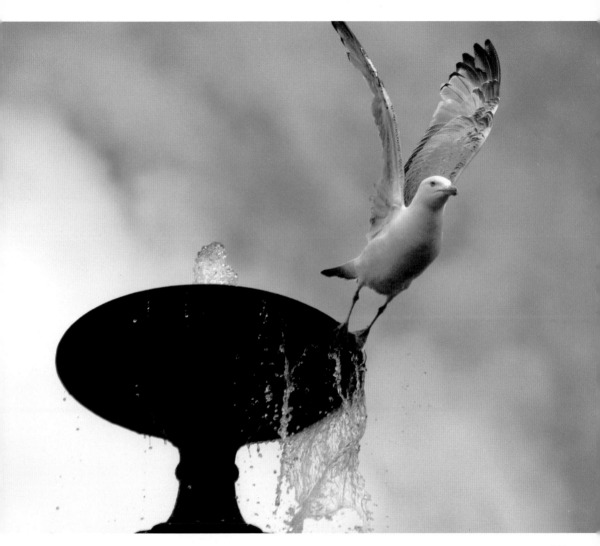

Close-Ups

There is a whole world of beauty and wonder, pattern, shape and colour just waiting to be photographed if you can get close enough. Luckily almost all digital cameras come equipped with a macro mode that lets you get within a finger's length of your subject, and often even closer, though with digital SLRs you may need to use a macro lens or attach a supplementary close-up accessory to your existing lens.

Indoors or Outdoors

There are two ways to choose a close-up subject. You can go out into the world and home in on leaves and plants, vehicle details etc., or you can create your own subjects at home – slice a kiwi fruit in half, or raid the children's toy cupboard. By careful use of composition it is easy to create images that show an unexpected, perhaps even unrecognizable, view of a normally familiar subject.

The Technical Aspect

There are, however, some technical challenges that must be overcome. Firstly, as you get closer to your subject the depth of field diminishes, until at very close range it is reduced to a narrow plane of just a few millimetres, even at the smallest aperture. This means that accurate focusing becomes critical. A tripod is essential for macro work because a tiny movement of the camera can make the difference between a picture being in or out of focus. For small-scale macro work a tabletop tripod is sufficient, though for nature close-ups in the field you will need a full-size one.

➡ *Wildlife close-ups can make stunning photos.*

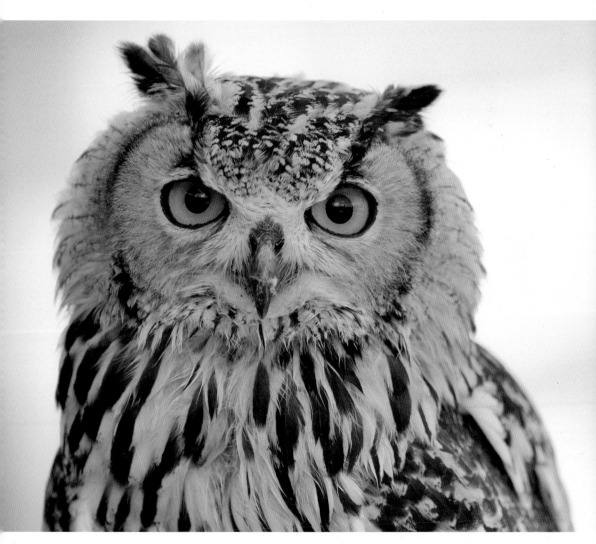

Focal Points

This shallow depth also means that you must exercise care in your composition, manoeuvring either yourself or your subject so that the important plane of interest aligns with the plane of focus. You can, alternatively, use this rapid loss of sharpness to your compositional advantage, using it to draw the eye to a sharp focal point in a sea of blur.

Selecting the Lighting

Lighting can be challenging at close range. Outside close-ups should be less of a problem – perhaps a small reflector to give daylight a helping hand – but indoors try experimenting with window light and artificial light such as table lamps. Does your subject look best with a soft, diffused light or a hard, directional one? As always, shoot many variations and check your results on the LCD screen as you go.

Top 5 Tips

➡ Look for subjects that are interesting or unusual at close range.

➡ Set your camera to the macro mode, if you have one. (Almost all compacts do.)

➡ Use a tripod. Fire the shutter using the self-timer to minimize vibration.

➡ You'll get minimal depth of field, even at small apertures. Make the most of this.

➡ Take care over your lighting. Review your efforts on the LCD to see how it looks.

⬆ *Unusual views of everyday subjects work well.* ➡ *You may need a tripod when shooting close-ups.*

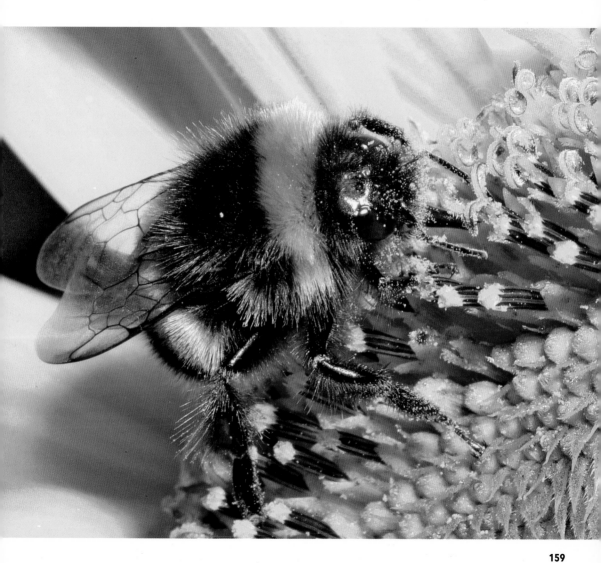

Still Life

A still life is a pictorial representation of one or more inanimate objects, arranged and lit in a visually pleasing way. It has been popular for centuries with painters and it is no less so with photographers.

Types of Still Life

There are two kinds of still life: the type you find and the type you create. Found still life subjects are often natural objects such as pebbles on a beach or fallen leaves in autumn. This also includes accidental art created by weeds growing out of a rusty bucket, or bottles on a windowsill. Still life subjects are all around us if only we look for them, though many need a little helping hand to maximize their potential – perhaps moving one of the elements slightly, or removing something distracting from the background.

Then there is the still life you create - on a table in the kitchen, or a studio light table. You bring all the elements together, arrange them, light them and photograph them. Any object is suitable, though if you are photographing a collection of objects it helps if there is a common theme. A still life of an apple, a razor and a toy train, for example, would not necessarily make much sense.

Lighting is Key

Both types of still life need common attributes. The most important of these is good, sympathetic lighting. Whether it be hard or soft, warm or cool, a still life will rarely inspire

➡ *The most ordinary subjects can become works of art.*

gasps of admiration if it is not exquisitely lit, and still life photographers spend hours adjusting the light.

If you are outdoors you can't change the light, but you can modify it with reflectors, diffusers or a blip of fill flash, or you can return another day when the light has changed. Indoors you are creating the light. Use the natural light from a window, or artificial lights, such as table lamps or professional studio lighting. Either way, use white or metallic reflectors and black card to direct and channel the light to where you want it.

Setting the Scene

With an indoor still life pay special attention to the choice of background too. Plain white is fine, but you can use textured art paper, foil, fabric, wood, sheet metal, ceramic tiles, piles of leaves or whatever you think appropriate.

Top 5 Tips

→ Look for natural still life subjects around you.
→ Create your own still life on a table at home.
→ With collections of objects make sure they have a common theme.
→ With a created still life, choose a sympathetic and attractive background.
→ Lighting is crucial. Spend time getting it right.

⬆ *Interesting shapes and patterns are all around us.* ➡ *Make sure you get the lighting right for the best effect.*

Architecture

Architecture is photogenic. From the pyramids and Stonehenge to the Guggenheim Museum and the Empire State Building, we love to photograph buildings, both ancient and modern. There are some difficulties though. We may not be able to stand where we want, because other buildings are in our way. The light may be coming from the wrong angle, or there may be too many people.

Picking Your Moment

The first thing to remember about buildings is that you cannot move them, so if the light is not where you want it, return at another time. Observe which façade the light strikes at a given time of day (a compass is useful here) and if you want to shoot the front, but it is west-facing, you know that you will need to return in the afternoon.

Avoiding Distortion

Having arrived at the optimum time, the next task is to locate a viewpoint that minimizes distortion of the building. In an ideal world you would be positioned in the centre of the façade, some distance back, with a telephoto lens. Assuming you can find a central spot, you will probably be quite close and will have to use a wideangle and tilt the camera upwards to capture the top. This results in 'keystoning' or converging

⬆ *Find an interesting viewpoint.* ➡ *Look for striking buildings wherever you go.*

verticals, where the sides lean in and the building appears to be toppling over backwards. There are two solutions: try to find a higher viewpoint – such as a balcony opposite, at half the height of the building you are photographing, or get it as straight as you can and correct the perspective later on your PC.

Zooming In

With many buildings there are lots of opportunities for close-up detail shots: gargoyles and ornate stonework on old buildings, radical angles and glass reflections in new ones. Use a telephoto lens to isolate them if necessary.

Cityscapes

Most cities also offer a high vantage point from where you can get good shots of the entire skyline. The best time is often early or late in the day when the sun is lower in the sky and less harsh. Evenings are particularly good because the buildings are often lit up, which adds an extra visual dimension. Go for wideangle views or pick out details with a telephoto.

Top 5 Tips

➡ Note which way buildings face and shoot at the right time of day for the best light.
➡ Shoot from a central position to minimize distortion. Avoid tilting the camera.
➡ With tall buildings try to find a higher viewpoint so you can keep the camera level.
➡ Look for interesting details that you can zoom in on.
➡ Shoot city skylines from a high vantage point. Choose sunset or night for drama.

➡ *Even fake skylines make a striking photograph!*

Interiors

There are so many beautiful architectural interiors in the world – in cathedrals, theatres, stately homes and other buildings – that you could photograph nothing else and never run out of subjects. But many photographers are intimidated by them, thinking that they require a great deal of specialized equipment.

Equipment Essentials

There are some basic equipment needs that will make life easier, but for many locations all you need is a tripod. There are, for example, many stunning modern interiors, often with vast expanses of glass letting in a great deal of natural light. A tripod lets the photographer ensure that the camera is completely level, and allows the use of small apertures for maximum depth of field, but is not essential.

Most interior photography, however, is of much older buildings, where light is low and a tripod is necessary – as is a decent wideangle lens, although if it is too wide you will struggle with distortion.

For general views of cavernous interiors such as cathedrals, set your camera up on the tripod at one end and make sure it is pointing straight ahead. Tilt it upwards and sides will appear to lean inwards – though in some cases, this kind of deliberate, exaggerated distortion can work well, especially to emphasize height.

⬆ *Look for natural frames when shooting interiors.* ➡ *Adjust white balance settings to accommodate different lighting sources.*

Challenging Light

In low light it may be tempting to increase the ISO rating, but this will reduce image quality so do this only as a last resort (e.g. you cannot use a tripod, or exposure times extended over a minute). Many interiors feature a mixture of light sources – perhaps tungsten lamps, with daylight coming through the windows. Since it is impossible to get both right, experiment with your white balance settings. If you can, shoot in RAW mode, as this will provide more colour correction latitude later.

If you have additional lighting with you, some interiors benefit from extra flash or tungsten light to fill in badly lit shadow areas. These will have to be used off-camera, and directed specifically into the areas that need it. A slave flash, which can be triggered remotely via a small blip from your on-camera flash, is perhaps the easiest to operate.

Interior Features

In your haste to get the wide shots, don't forget to look out for interesting details to isolate: perhaps an ornate banister, a spectacular chandelier, a painted ceiling or a stained glass window.

Top 5 Tips

➡ Take a tripod, to keep the camera level and enable small apertures.

➡ Use a wideangle lens, between 24 mm and 35 mm (equivalent).

➡ To avoid distortion keep the camera level and avoid ultra wideangles.

➡ Fit a longer lens to isolate interesting details. Look for unusual angles.

➡ Keep the ISO as low as possible. Use off-camera flash if necessary to fill shadows.

➡ *Bright interiors will not require flash.*

Night & Low Light

Night time can often provide some of the best photographic opportunities, especially in urban areas. The most obvious subject is architecture. Churches and grand civic buildings are often beautifully lit and can look better at night.

Ideal Time to Shoot

Don't wait until it is dark – dusk is the best time to shoot, when there is still enough ambient light in the sky to fill in the unlit parts of the building, and reduce the contrast between those parts and the areas bathed in the spotlights. A navy blue dusk sky also helps to highlight the outline of the building. Set the camera to RAW mode (if possible –

if not, use daylight white balance in JPEG mode) and the lowest ISO you can, put the camera on a tripod, stop down to f/8 of f/11 and see what exposure time the meter gives you. It may be anything from 10 seconds to more than a minute. Try to avoid exposures much longer than this, as it will increase the noise levels in the image. Wait for a gap in

⬆ *Dusky skies can intensify colours.*　⮕ *Neon signs come alive in low light.*

traffic before shooting, though fast-moving people will probably not record on the image during long exposures.

Great Night-time Subjects

One of the most fun things you can do at night is shoot traffic trails, where you deliberately focus on a busy road and allow car head and tail lamps to record as streaks during an exposure anywhere between 10 and 30 seconds. Try to include the backs of cars as well as the fronts, so that you capture both red and white streaks. Funfairs are another occasion where moving lights make great pictures. Illuminated rides such as Ferris wheels can produce wonderful streaks of blurred colour during long exposures.

You can also photograph fireworks displays. With a standard lens or slight wideangle fitted, set the camera up on a tripod, pointing at the sky. When the fireworks go up, open the shutter to record the burst. If you have a 'B' setting keep the shutter open, replace the lens cap, then open it again for the next burst, building up several bursts on the same exposure. Failing that, use the longest exposure time available, or take several shots and combine them into one image later.

Top 5 Tips
➡ Take a tripod.
➡ Use the lowest ISO you can, select RAW mode or daylight white balance in JPEG.
➡ Shoot aT dusk, when there is still some colour in the sky, not when it is pitch black.
➡ Stop down to f/8 of f/11 and keep exposure times between 10–60 seconds if possible.
➡ Try shooting traffic trails, fairgrounds and fireworks, for great motion effects.

➡ *Cityscapes offer lots of inspiration for night pictures.*

Using Your Computer

Setting Up Your Computer for Digital Photography

For people using 35 mm photography, the entire post-production process simply means sending a film to a laboratory for processing. Digital photography is different – you can manipulate, print, organize and store images in your own home using a computer.

Your Digital Darkroom

Once you have a digital camera you need to think about your digital darkroom setup. The digital darkroom refers to the equipment needed to process and print your photographs. The nerve centre in the darkroom is a computer – used for transferring, editing, organizing and printing. Position the computer in a place you feel comfortable working, ensuring you have plenty of light and space for your camera and any hardware such as a disc burner, printer and scanner. Each separate device connects to the computer through a USB (Universal Serial Bus) lead. If you are going to send your pictures by email or post them on the internet, you should also make sure that you are near to a phone socket or broadband connection.

Laptop Benefits

Many professionals use laptop computers for downloading images on location, because the fold-down screen is easily transported. If your main stipulation is convenience then this portable option is worth considering, although it is worth bearing in mind that laptops are, pound for pound, less powerful than desktop computers.

➡ *A laptop takes up less space on your desk and can be easily transported.*

Equipment to Invest In

It is essential to back up your photographs, so a CD burner is a worthwhile investment. Many new computers already have one built in, but if yours does not, internal and external burners can be easily bought on the Internet or from high street electronics shops. Internal drives are cheaper but need to be fitted, whilst external devices are slightly more expensive, yet portable. Investing in a printer to print out your photographs is another consideration and there are a wide range to choose from – although thanks the abundance of photo printing services it is not essential.

Software to Invest In

Depending on your interest in photo-manipulation you may need to buy some software. You can view images as thumbnails and perform very rudimentary image editing using Microsoft Paint (part of the Windows XP package), and digital cameras are supplied with basic software such as Olympus Master 1.1 or Fujifilm FinePix Viewer that can upload pictures and perform basic image-editing functions. For more intermediate editing, Adobe Photoshop Elements or Corel Paint Shop Pro offer more tools and scope for creativity for under £100, while Adobe Photoshop CS2 is aimed at professionals and costs approximately £450 plus VAT. Ensure that you have sufficient space on your hard drive before installing any programs – Photoshop CS2 requires 650 MB of hard-disc space and 320 MB of RAM.

⬆ *Adobe Photoshop CS2 is aimed at professional photographers* ➡ *Burning your images on to disc is a good way to back them up.*

Transferring Pictures from Camera to Computer

Digital photographs are stored on interchangeable memory cards or in the camera's internal memory. In order to edit, manage and archive them you need to transfer the images on to a computer from the camera. This process varies slightly depending on the make and model of camera. The majority of digital cameras are supplied with a USB cable, which connects to the camera and plugs into a port on your computer. You can then transfer images by following the instructions displayed on the LCD screen.

Using a Docking Station

Some digital cameras are supplied with a docking station that connects to your computer using a USB port. Once you activate the dock, the images are uploaded directly to your computer. Docking stations can stay permanently connected to your computer, making them a convenient option.

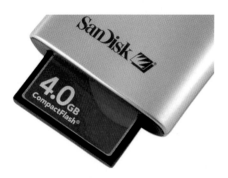

Using a Memory Card Reader

Memory card readers are one of the most straightforward methods of transferring images from camera to computer. You connect the reader to the USB port on your computer and insert the card into the slot. A wide range of readers are available that are compatible with singular or multiple types of flash cards. The

⬆ *A single format card reader.* ➡ *Cameras with docking stations can save a lot of time.*

reading devices are usually small enough to stay permanently attached to your computer, and because you do not have to keep connecting and disconnecting a camera they are particularly useful in households with more then one digital camera.

Accessing and Transferring Images

Once you have transferred your photographs onto your PC you can choose to access them directly through Windows, or to use the software supplied with your digital camera. If you use Windows an icon appears on the My Computer interface entitled Removable Disk. Double-click it to access a folder called Digital Camera Images (DCIM). This contains a folder that has been given a generic name by the camera; the name varies between different manufacturers, but will include a sequence of numbers and letters such as '100OLYMP' or '729 CANON'. Transfer the images by dragging the folder directly on to your desktop or to a specific location such as the Windows My Pictures folder – a pop-up box will appear to inform you of the transfer's progress.

Newcomers to digital photography may find it easier to access their photographs using the software supplied with their camera. Connect the camera to the computer, fire up the program and follow the on-screen instructions to locate the pictures and transfer them on to your computer's hard drive (its main storage area).

⬆ *Some memory card readers are compatible with multiple card formats.* ➡ *Accessing your images should be straightforward.*

Transferring Pictures from Mobile Phone to Computer

While mobile phones still cannot compete with dedicated cameras when it comes to image quality or functionality there is one area in which the camera phone comes out on top: connectivity and sharing. While a camera must be plugged into a PC or its card removed and inserted into a card reader, images from camera phones can be shared and transferred instantly in a variety of ways.

Photographs can be transferred from a mobile phone by connecting it directly to your computer and then accessing pictures in the same way you would a digital camera, or by using software supplied with the phone, such as Nokia PC Suite.

Memory Cards

Sophisticated camera phones can also store photographs on removable memory cards – most phones include a slot for a Micro SD or Memory Stick Micro (M2) – which are slightly smaller then those used in digital cameras. Remove the card from the phone and you can transfer pictures to your computer using a card reader, although it is worth checking the compatibility because you may need to buy an adaptor.

Setting Up MMS

Another method of sending photographs to a computer is through Multimedia Messaging (MMS). Data is sent over a General Packet Radio Service (GPRS) or Global

➡ *Phone memory cards can be very small.*

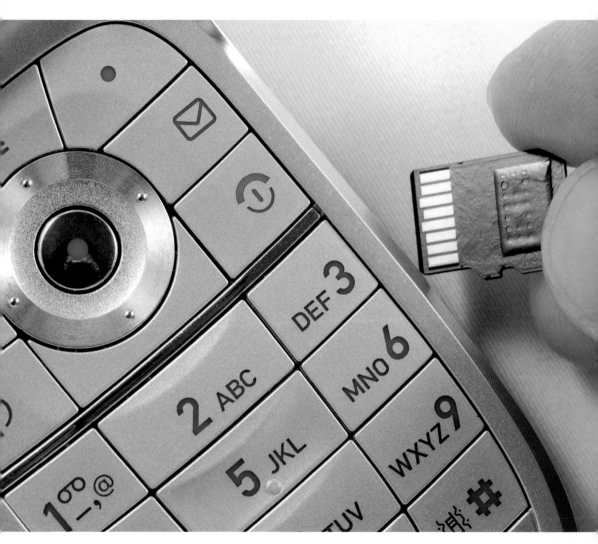

System for Mobile Communications (GSM) network directly to an email address. In order to use this you need to ensure that MMS settings are installed in your phone. You can find out the settings from your service provider by contacting them directly, or alternatively you can visit the support section on your phone manufacturer's website. By selecting the type of phone and network operator, the settings can often be sent as a text message directly to your phone.

Wireless Technology

Modern phones are increasingly equipped with Bluetooth technology. Bluetooth enables you to connect your phone to devices such as computers, phones and PDAs wirelessly without the need for any cables. You will need to turn on the Bluetooth facility on your phone, and it will then search for any devices that are within range. Once it has located the computer it can send the photograph. In order for the connection to work, you need to be about 10 m (33 ft) away, and although the phone doesn't have to point directly at the computer, walls may hinder the transfer. Not all PCs are Bluetooth-enabled, so you may need to buy a USB adaptor. Some printers are now Bluetooth-enabled, allowing photographs to be sent directly from a phone to a printer.

⬆ *Use MMS to send picture messages directly and quickly.* ➡ *You must enable your phone's Bluetooth facility before sending images.*

How to Open a Photograph

Once you have taken your pictures and transferred them on to your home computer you will want to open them. The easiest way to do this in Windows is to locate the folder containing the photographs, go to the View menu and select Thumbnails.

Each photograph in the folder will be displayed at the same time at a greatly reduced size as a small thumbnail whilst still enabling you to see what each picture is and to differentiate between them. To display your picture in a slightly larger format, return to the View menu, this time selecting Filmstrip. Windows includes a Picture and Fax Viewer that you can use to view your images at an even bigger size, in a way similar to viewing a slideshow. You can scroll through the images using the controls along the bottom, enlarging them by using the magnifying glass icons, and viewing them at full size by hitting the Actual Size icon. If your pictures are the wrong orientation use the green triangle icons to rotate them.

Using Image-editing Software

If you are intending on performing specific image-editing functions (such as cropping or adjusting the brightness and contrast) it may be better to open your photographs directly within the program you are going to use, such as Adobe Photoshop Elements or Corel Paint Shop Pro. Go to the File menu and right-click Open – a box will appear that you can use to access the files from their current location on the computer.

One of the most effective ways of opening a photograph is to use a file browser. Found in the majority of image-editing programs and in software supplied with the camera, a file browser views the contents of a folder as thumbnails with information telling you when each picture was taken and the camera settings used. This is particularly useful to identify a specific photograph when you have numerous pictures in the same folder, and you can view them all at the same time without having to open them individually.

If you always use the same piece of software to open a specific type of file, Microsoft Windows can assign file formats to the program. File formats open the files using the specific program each time you double-click on a file, instead of using the default settings.

⬆ *Cropping an image in Photoshop.* ➡ *In Photoshop CS2, the file browser is located in the Adobe Bridge section.*

Organizing your Images:
Naming & Filing

The immediacy of digital photography means that more people are taking photographs then ever. This is partly because you can preview your image on the LCD screen of your digital camera, deciding whether to delete or not, which is in direct contrast to film photography where you could never be quite sure of the results until the film came back from the developers.

A consequence of having so many images is that without some organization, your hard drive will soon be overrun with photographs all with impenetrable file names, so it is useful to implement a filing system. If you only use your camera occasionally – perhaps on holiday or birthdays – you can do this manually by creating a system of folders.

Renaming your Photographs

Once you have transferred your images on to your hard drive the first thing to do is replace the file extension generated by the camera – this is generally a sequence of numbers like 1010080 or IMG_4309 that offers little useful information – into something

⬆ *Select a new name and location with Batch Rename.* ➡ *Generic names created by your camera can be confusing.*

comprehensible. In fact, if you reset your memory card the file numbers will revert back to the beginning, which means you could have several files with the same name.

It is labour-intensive to change the names of numerous digital files individually. Photoshop Elements and Paint Shop Pro have a Batch Rename tool that changes the names of multiple pictures within seconds. Open the file browser in Photoshop, highlight those thumbnails you wish to rename, activate the Batch Rename command and enter a name – such as 'Summer Holiday 10' – and it will be allocated to each photo along with a sequential number.

Filing your Pictures

It is a good idea to have a system of folders in place to which you can transfer images once you have renamed them. The most straightforward method is to create a series of named folders for different types of photographs, including holidays, birthdays and pets. Within each genre of photographs you can include sub-folders that are more specific, for example 'Tenerife 2010' or 'Sarah's 14th'. Every time you upload new images it is easy to simply rename them and drag them to their new location.

⬆ *Make sure each folder has a logical name.* ➡ *Individual names are much easier to locate.*

Creating a Photo Library

While manually organizing your photographs into folders may work for a hundred images, if your digital photographs run into the thousands it is more practical to create a photo library using specialist software. There are a wide array of programs available: Adobe Photoshop Album (which is included within Photoshop Elements) and Corel Photo Album are suitable for novices, while Extensis Portfolio and ACDSee are aimed at professional photographers and frequently offer RAW support.

Using Management Programs

Every time you transfer new photographs on to your computer, open them using a management program so that it can record relevant information for each file. Extensis organizes your photographs into catalogues, which contain thumbnails of every picture with a relevant name – anything from 'Wildlife' to 'Holiday 2010'. The catalogue also retains Exchangeable Image File (EXIF) data from the camera, detailing camera settings and any additional details you want to add, which could be keywords, a brief description of what the image is, copyright information and the file name. You can have

⬆ *You can organize your images with ACDSee.* ⇒ *Use the Catalog Files Wizard to add image information to ACDSee.*

as many or as few catalogues as you want and can keep adding to existing ones or categorize them further into separate galleries. In ACDSee thumbnails of photographs are stored in a central database, which you can organize into categories and sub-categories.

Where Are the Images Stored?

In common with many file managers, Extensis and ACDSee do not actually change where your computer stores your digital photographs (unless you specify it); rather, each catalogue acts as a portal of thumbnails to help you find a specific image, which doesn't even have to be stored on your hard drive, but could be on an archived CD. It is also much quicker to display, making it easier to find a specific image.

Using Keywords

When you search for an image, enter one or more keywords and the program will then scour your hard drive looking for a match and display thumbnails for each of the resulting images. Both Photoshop Album and Paint Shop Pro have this feature. Keywords can be anything from the type of occasion, such as a birthday, holiday or day out, to the name of the person in the picture, or a photographic genre such as travel, nature or macro. You can usually assign several keywords to each picture.

Program Bonuses

Many image-management programs complement photo-editing software. The Extensis Portfolio Express features floating palettes that can be accessed within Photoshop without the full program being opened – this helps you to search quickly for any photograph on your hard drive.

➡ *Add keywords or brief descriptions to your catalogues for easy navigation.*

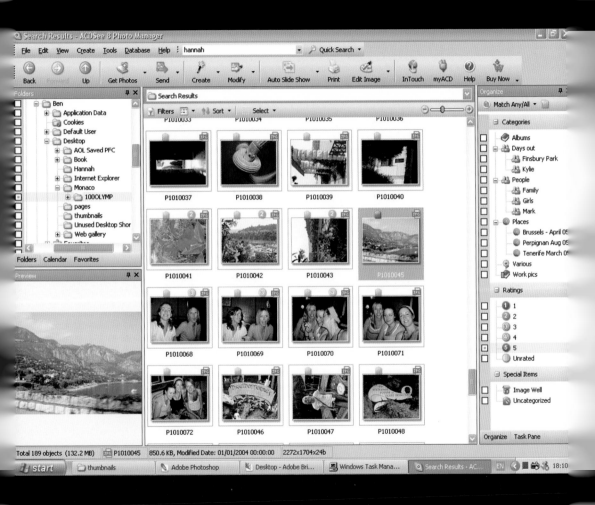

Living Without a PC

You can tinker with your digital photographs on a computer to enhance them or create something artistic, and while many people will invest in a PC, it is a myth that you need one in order to enjoy digital photography.

Touching-up Images

Recently some manufacturers have introduced technology into their cameras that can be used for rectifying common photo problems, which means some edits you perform on a PC can now be done in-camera. Most new HP cameras incorporate Real Life Technologies enabling common photo problems, such as red eye or underexposed highlights, to be corrected in-camera and Nikon has a similar process with D-Lighting and In-Camera Red-Eye Fix. While useful, this technology is still in its infancy and does not yet provide the flexibility of Photoshop or Paint Shop Pro.

Printing Without a PC

Most digital cameras and photo printers are compatible with the PictBridge universal standard, so that you can print directly from any compatible digital camera to any compatible printer without the need for a computer or additional software. Canon, manufacturer of cameras and printers, has its own standard, Canon Direct Print, although its products are compatible with PictBridge as well. To print directly from your camera, connect it to the printer using a USB cable and instructions will appear on the LCD asking which photographs you want to select and how many copies you want to print.

➠ *Some printers come with a camera dock which makes printing very easy.*

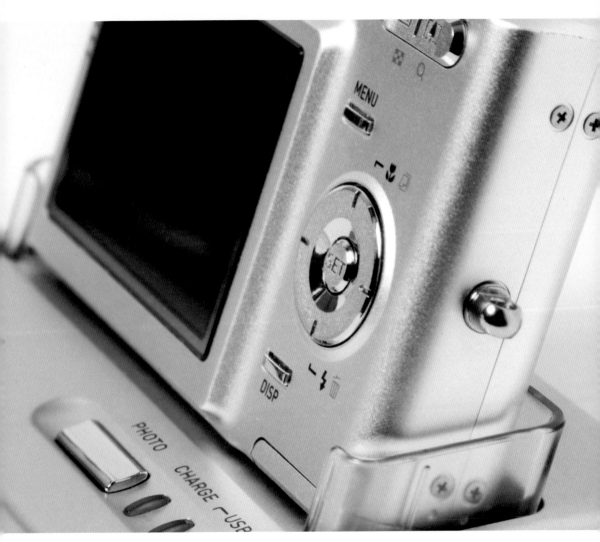

Printer manufacturers are increasingly recognizing that not everyone wants to use a PC and many new printers include card slots compatible with a range of flash memory cards, enabling prints to come directly from a memory card.

The majority of new digital cameras support Direct Print Order Format (DPOF) so that you can select in-camera the photographs you want to print. When the camera is connected to a printer (or the memory card is put into the slot) the printer will

detect automatically which images you want to print. This is a great timesaving feature and means you do not have to scroll through hundreds of pictures to find the select few.

If you do not want to print your pictures you can take your memory card to a photo developer. Specialist photographic retailers such as Jessops and even supermarkets can produce prints directly from a memory card. (See pages 246–49 for more on using a printing laboratory.)

⬆ *Some printers allow you to print directly from a memory card.* ➡ *Kodak printer docks enable you to print directly from the camera.*

Sharing Your Photographs

One of the most enjoyable elements of photography is sharing your pictures, either to relive memories or to share an event with someone who missed it. Digital photography makes sharing pictures easy, because pictures are stored as computer files and you can attach them to an email or upload them to an internet photo gallery.

How to View Your Photographs on the TV

The television is an ideal device on which to view digital images. Many digital cameras have a video out facility and come supplied with an Audio and Video cable (A/V) that connects to the camera at one end, and to the white and yellow audio and video point on a television at the other. Very often, modern televisions have a SCART rather then an AV connection and if this is the case you will have to invest in an adaptor. In order to see the images you will have to turn the television to the AV channel, before using the controls on the back of the camera to scroll through still images and view video clips. Some

⬆ ➡ *You can slot your memory card straight into these devices and see your images on TV.*

cameras have the facility to create a simple slideshow from your digital images, which you can then view on TV.

Photo viewers are becoming increasingly popular ways of viewing images on a television. The SanDisk Photo Viewer and the TV 6-in-One Photo Album are small, flat devices, which connect to your television (again through the AV point) and are designed to sit on top of your DVD player or TV. You can display pictures by inserting a memory card into one of the slots at the front and scroll through the images using the supplied controller. Some devices also enable you to create slideshows from your images, which can be saved on to a memory card.

Using a DVD Player

Slide shows are useful for archiving images, and also for sharing pictures. With prices dropping as low as £30, increasing numbers of households have DVD players, which makes creating a DVD slideshow of your pictures an alternative way of watching them on television. CD/DVD slideshows are more personal; you can choose exactly which photographs will appear and for how long, create captions and add fun sound effects. Operation is very straightforward - put the disc into the DVD drive and hit play.

⬆ *The SanDisk Photo Viewer includes a remote.* ➡ *The TV 6-in-One Photo Album connects to your television through an AV point.*

How to Make a Simple Slideshow

In Windows XP you can make a basic slideshow by opening the folder containing your pictures and selecting View as a Slideshow from the picture task options. The monitor will automatically switch to full screen. Once you hit 'play' it will start scrolling through the images, or you can skip through them by clicking 'page up' and 'page down'.

There are a host of programs enabling you to create slideshows complete with transitions and effects that you can burn on to CD and watch on television. Ulead CD and DVD PictureShow is a good option for beginners. Like many slideshow creation programs it functions in a step-by-step format, making it incredibly user-friendly.

Where to Begin?

Start by locating your photographs – which you can usually do using a file browsing system to find the folder containing your images – and choose which ones you want to incorporate into the slideshow. In Ulead CD and DVD PictureShow the selected pictures are displayed as thumbnails, which you can add to the program on their own or as a group, before dragging them into your chosen order. It makes sense to ensure the order is logical; if the subject of your slideshow is a summer holiday, avoid beginning with a photograph taken at night or towards the end of the holiday.

Advanced Slideshows

You can make adjustments to the exposure of individual pictures and add captions using most slideshow creation software. If you are interested in creating more advanced slideshows, you might consider investing in Magix Photos on CD and DVD. Utilizing a timeline format similar to that found in video-editing programs, software, pictures, transitions and sound effects are all positioned on different channels.

Slideshow Effects

In the majority of slideshows you can specify how long each photo will appear and choose to add transitions, such as fades and wipes, pan and zoom effects or photo frames. You can also add music or use sound effects supplied with the program, which

you can run on a loop so that it matches the length of your slideshow. Most slideshow creation software includes a selection of DVD templates that you can personalize. The quality of the templates varies – they are often organized into themes, including birthdays and holidays, and may not be to everyone's taste. When you have completed your slideshow you can burn it on to CD or DVD and share it with family and friends.

⬆ *Most slideshow software has a range of backgrounds you can use.* ➡ *In Magix Photos you can add music, frames and wipes.*

How to Send Pictures by Email

Email is increasingly used as a method of communication because it is virtually instantaneous and enables vast quantities of files – including digital photographs – to be sent quickly. Three types of email are commonly used: a home Internet Service Provider (ISP), email through work or school or a free service from an online search engine.

Attaching Files to an Email

For a monthly fee Internet Service Providers such as Tesco or AOL give you a selection of email addresses when you sign up. The actual process of attaching a digital photograph depends on the program – you can send it as an attachment or embed it into the file. In AOL click Attach File and a pop-up box appears that you can use to locate the folder containing your pictures, before selecting the ones you want to add, then clicking Open.

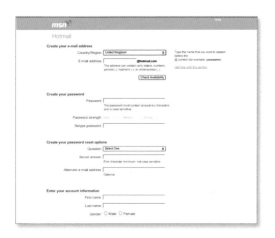

Sending Personal Emails from Work

With the majority of work-based communication taking place via email, it is inevitable that some people will email photographs from work. Whether this is allowed or not depends on the policy of the

 Mail

Yahoo!-Help

Already have an ID or a Yahoo! Mail address? Sign In.

Fields marked with an asterisk * are required.

Create Your Yahoo! ID

* First name: []

* Last name: []

* Gender: [Select] ◆

* Yahoo! ID: [] @yahoo.co.uk
ID may consist of a-z, 0-9 and underscores.

* Password: []
Six characters or more; capitalization matters!

* Re-type password: []

If You Forget Your Password...

* Security question: [Select a Question] ◆

* Your answer: []
Four characters or more. Make sure your answer is memorable for you but hard for others to guess!

* Birthday: [dd] [Select a Month] ◆ [yyyy] [?]

* Postal code: []

* Country: [United Kingdom] ◆

Alternate Email: [] [?]

Special Offers

☐ Contact me occasionally about special offers, promotions and Yahoo! features. More information here.

Verify Your Registration

* Enter the code shown: [] More info ⬚
This helps Yahoo! prevent automated registrations.

V752

individual employer, but many actively discourage it, so it is worth checking your contract before sending personal photographs this way.

Signing Up

The advantage of using online websites such as Hotmail, Yahoo and Google is that they can be accessed from anywhere in the world, which is very useful if you are travelling and want to email your photographs home. With Hotmail you can send files up to 10 MB and utilize around 250 MB of storage, while Yahoo has 1 GB of storage. To obtain an email address you will have to sign up for an account by entering basic information and choosing a name.

File Size Issues

Before emailing your photographs you need to ensure that they are the right size, especially if manipulation has been performed in Photoshop and you have saved the file as a TIFF. JPEG is the preferred format for emailing digital photographs. The file size is much smaller than TIFF files, so you can email several files at once. Remember, the more compression you apply to an image, the more the quality will diminish. If your photograph is too large the upload may be very slow - especially if you do not have broadband and are trying to transfer numerous files. Many providers limit the file size of each email you can send - AOL sets a maximum of 16 MB to sent files, while others have a 1 MB limit on files you can receive. If you are in doubt, check with your provider and the person to whom you are sending the images.

⬆ *Gmail's storage space is always growing.* ➡ *Make sure your photos do not exceed the provider's file size limit.*

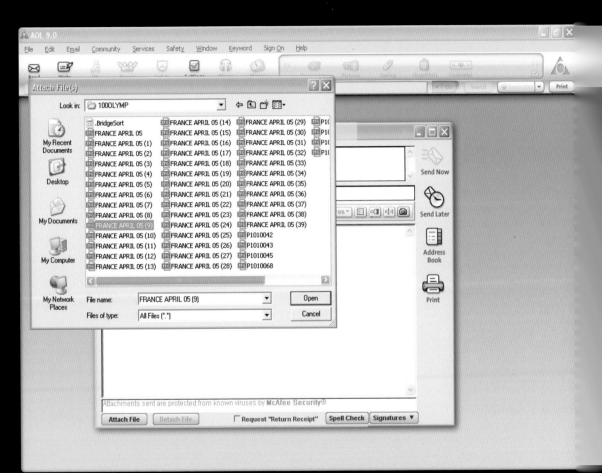

How to Take Pictures with a Mobile Phone

Most mobile phones have built-in cameras. While image quality is not up to the standard of proper digital cameras, it is fine for a quick record snap on those occasions when you do not have a camera with you. Taking pictures using a mobile phone is easy, and since there are fewer functions to worry about, there is arguably less to go wrong.

Accessing the Camera

Every mobile phone has different controls and the camera is accessed in a slightly different way. With most phones it is done via the menu, often a shortcut menu, and on most phones you can assign one of the buttons as a shortcut to the camera. Once the camera is on you will see your camera's view on the LCD screen. If your phone has an exposed lens you may find the image a little fuzzy or hazy, and this is likely to be caused by a smear or finger mark on the lens, caused by holding it as a phone. If this is the case, give the lens a wipe.

⬆ *You can create a shortcut to the camera.*　➡ *Make sure the camera lens is clean.*

Camera Settings

There will probably be an options menu where you can select the shooting mode, focus mode, resolution, flash mode (if you have a flash), self timer, white balance and other settings. It is always best to select the highest resolution unless you only intend to send the image as an MMS message.

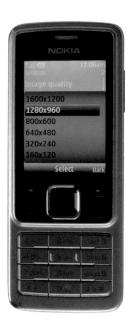

What Next?

Some phones have a dedicated shutter button; if not it will be the main input button. Once you have taken a picture you will be asked what you want to do with it. You will generally be asked to choose between saving it, editing it or sending it. If you want to do the latter, you'll be asked whether you want to send it as a picture message, post it on a website or Bluetooth it – perhaps to someone else's phone or a printer.

Stored photos are held in the media section of your phone, from where you can view them as a slideshow or set one as your phone's wallpaper.

⬆ *Always rename your shots and choose the largest file size.*　⮕ *Set great images as your wallpaper.*

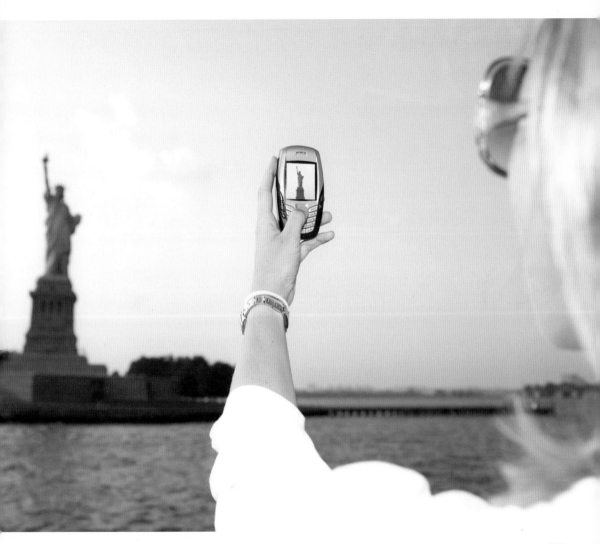

How to Use an Online Sharing Website

There are many online photography websites where you can display your images for free and meet like-minded photographers.

You can upload one photograph a day to www.ephotozine.com and the photos appear in a gallery of reader pictures and are stored in an individual portfolio. As well as offering a print service, you can upload your pictures into a gallery with 200 MB storage on www.photobox.com. By entering the email addresses of friends or relatives you can share your gallery with others.

Online Comments

Many photo-sharing websites include message boards, which you can access by registering, so that you can comment on other people's images as well as inviting criticism of your own and getting shooting tips – a great way of improving your photography and generating healthy debate. Many people enjoy being part of an online community and these sites are well known to photography fans, often with

⬆ *Uploaded images are displayed as thumbnails.* ➡ *There are a variety of ways to upload to PhotoBox.*

PhotoBox

My Albums | Add Photos | My Details | Create Album | View Basket

Items: 0
- Empty basket
- Checkout

- Photo Gifts & Cards
- Services & Prices
- Quality Advice
- Public Albums
- Pro Galleries

[My Albums ▾]

Join our monthly newsletter to receive great discounts by email

Find a gift
- 12-pg calendars NEW
- photo mugs

What's new?
- 20% off early gifts
- Send eCards NEW
- MMS postcards NEW

- Greeting cards
- passport & stickers
- contact sheets
- archive CD & DVD
- posters & **7p prints**
- refer-a-friend!

New highest quality 12 page

← Back | ♠ Front Page

Add photos

help on uploading | show recent uploads

Upload JPG photos through this page. If you prefer you can upload by <u>email</u> or <u>FTP</u>.
Please do not click onto a different page whilst adding photos! **You must not violate anyone's copyright by uploading images to our web site. If in doubt please <u>contact us</u>.**

Step 1. Where do you want to store your photos?

Album: [Holiday pictures ▾]

Step 2. Choose your files.

If you prefer standard browser uploads, you can upload photos using the form below.

<u>Show more boxes</u>

[_____] (Browse...)
[_____] (Browse...)
[_____] (Browse...)
[_____] (Browse...)
[_____] (Browse...)
[_____] (Browse...)
[_____] (Browse...)
[_____] (Browse...)
[_____] (Browse...)

thousands of members. Search engines such as Yahoo also provide online storing space, although there is less emphasis on photographic technique.

Signing Up

To join an online sharing website you will need to sign up. On ephotozine this involves choosing a username and entering basic information including your email address and password. Before uploading your pictures, you will need to ensure they are saved at the correct file size, which will vary depending on the site – ephotozine specifies that each picture is 500 pixels in size, less than 600 K and in JPEG format.

Legal Issues

As an amateur photographer you own the copyright of every picture you take, but once your pictures go on to the Internet they are in the public domain and could be copied by other photographers. There is no way of preventing this, although Photoshop can add a watermark to your image – such as the date and name – and embeds it into the file so that it cannot be removed. You will need to register with the Digimarc Corporation (www.digimarc.com) first. It is also worth adding a caption containing your name and the year to the bottom of your photograph.

Be aware of issues regarding content. Whether it is right or wrong to upload photographs of children has provoked heated debate and while the majority of photographs are innocent, if you want to upload images of a child's birthday party to your website it is best to obtain permission from the parents first. Airport check-in desks, army bases and banks are other potentially problematic subjects. Sexism, racism and political discontent are also contentious.

➡ *Invite comments from others at websites such as ephotozine.*

ePHOTOzine

Login or Register

£50 Cashback with Nikon D50

Home

Search

News

Directories

Forum
Recent activity

Equipment
Shop
Compare Prices
Camera Phones
Reviews
Buyers' Guides
Classifieds
Instruction Manuals

Photos
Online Printing
Reader Gallery
Modifiable Photos
Editor's Choice
Reader Portfolios
Photo Competitions
Pro Portfolios
Photo Locations
Exhibitions

Learn

Home / Photos / Reader Gallery

Reader Gallery

Photos of the Week gallery
Readers' Choice
Most viewed photos
Recent comments
Search gallery

 Upload a photo

Page 1 of 14490 pages - Next > End >>

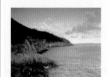
Trinny

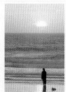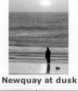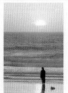
Newquay at dusk

Bygones 4

red tomatoes

Early morning Cliffs

sleeper

m **F8**

Motherhood

225

How to Use a Template
to Make a Web Photo Gallery

A web gallery is a very effective way to share your digital photographs, and is made up of thumbnails of pictures that others can click on and view. A gallery can be viewed from anywhere in the world and by anyone, making it a great way of sharing images.

Choosing a Domain Name

There are companies that will create websites for you, but the development of software means it is easy to build your own web gallery fairly quickly – Photoshop even has a Web Photo Gallery feature that does the hard work for you. Many people will want to select the domain name of their website. You can choose anything, although if you are planning on using it to sell pictures, select something that sounds professional. There are a range of places where you can buy domain names for an annual charge, including www.pickaweb.co.uk and www.123domainnames.co.uk. It is possible to obtain a domain name for free, although if you opt for one of these you will not be in complete control of the site.

Finding a Host

The next step is to find a web host who, for a monthly fee, will provide you with space online and email addresses. There are many Internet Service Providers (ISPs) offering packages to suit different budgets, so shop around. It is worth finding out the hours and cost of telephone support in case you have any problems. If you don't want to create your own website, many service providers give you free online space. BT Yahoo Internet and Tesco Internet Access offer you 15 MB of Internet space and include software to help you create a website.

➡ *A personal website is a great way of displaying your work to a wider audience.*

◄ ► | C | + | 🌐 http://www.nigelatherton.com/ ⊙ | ^ | Qˇ Google

📖 Search ▾ WDC me BBCi IPC Media WorkWeb Yell BT.Com eBay IMDB Play Argos lastminute Amazon Apple AA RadioTimes Kids

nigelatherton.com

NIGEL ATHERTON *photographer*

home

● **gallery**

 cuba
 japan
 kenya
 morocco
 las vegas
 misc travel
 35mm travel
 brighton & sussex
 family

about me

links

contact

G a l l e r y

cuba

japan

kenya

morocco

las vegas

misc travel

35mm travel

brighton & sussex

family

Designed by Subtense Powered by Clikpic

Preparing Your Images

You will need to prepare your images, source them from the hard drive or CD and deposit them into a folder before you upload them. Avoid working on your original files, and instead make copies – Photoshop automatically does this, but some programs may not. It is important to choose the order of your photographs carefully. You will need to rename your files individually or by using a batch renaming feature.

Using Photoshop to Create a Web Gallery

Step 1
Collate the files you want to include in the web gallery and put them into a folder. In Photoshop head into the File menu and select Automate, then scroll down and select Web Photo Gallery.

Step 2
Click on the drop-down menu next to Styles and choose a style for your gallery. Hit the Browse button to locate your folder and use the Destination button to choose where to put them.

Step 3
Personalize your gallery with the drop-down menu. Select Banner to enter a title and author. Choose how big each photograph and thumbnail is with the Large Images, and Thumbnail menus. You can add text over each picture using Security.

Step 4
Photoshop will automatically resize all the images and put them in a folder along with thumbnail images, HTML pages and a preview screen of the website that you can view in your browser.

Printing at Home

With film photography, most consumers hand the roll of film to a chemist and return an hour later to collect their prints. Digital photography is different – you can choose exactly what to print and you have the option to print it yourself.

Why Print at Home?

A digital photograph is a chain of events that begins when you look at the scene, choose the right camera settings, press the shutter and preview the shot in the viewfinder. Then you take part in the post-production process by uploading your picture on to the computer and making tonal adjustments so that it looks exactly the way you want. The final link in the chain is printing.

One of the major advantages of printing at home is convenience – you don't have to trudge to a shop and then return to pick up

↑ ➡ *Print directly from your camera or using a home computer.*

prints, or wait for them to be delivered. You can turn on your PC and start printing – and it can be very rewarding to print your own pictures.

Home printing may initially seem daunting: colour management, size and resolution are just some of the areas you need to understand and we will look at them in detail later.

However, printer manufacturers are realizing that more people want to print at home and are producing user-friendly devices such as the Kodak Printer Dock and Epson Picture Mate. Once you get used to your printer and understand how it works you will be able to print quickly and – crucially – be able to control exactly what you print.

The Cost of Printing

While the cost of ink and paper can be pricey and home printing cannot match some of the deals on the high street, it is increasingly affordable. Many households already have document printers, which may be able to produce photo-quality prints by using different paper or ink. The price of new printers is dropping – an adequate inkjet printer can cost less than £100.

⬆ *Make sure you have the right ink and paper.* ➡ *The Epson Picture Mate features a carrying handle, allowing you to print on the go.*

How to Make a Print:
Sizing & Resolution

Before you start printing it is important to check that your camera is capable of producing good-quality prints at the size you desire. The number of pixels in your camera determines the size you can print – the greater the number of megapixels there are, the larger the prints you can produce.

The key is quality – the lower the resolution, the fewer pixels per inch and the more chance there is of the space between the pixels becoming visible to the viewer. It is generally stated that the minimum resolution you should print at is 200 pixels per inch (ppi), with some quarters recommending 300 ppi for photographic-quality prints.

Print Sizes

Here are some approximate print sizes for typical digital cameras. If you use an image resolution of 200 ppi the maximum image size a 2 MP camera is capable of producing for optimum quality is 20 x 15 cm (8 x 6 in), whereas a 9 MP camera can produce prints as large as 44 x 33 cm (17 x 13 in) at 200 ppi. It is possible to produce A4 prints from a 2 MP camera at a resolution of 120 ppi, but the quality may not be particularly high. This is not an exact calculation as printers do not print the image out as square pixels, rather they convert the image into one made up of round dots through a process known as dithering. A good inkjet printer may have a printing resolution (the number of dots used) of 2400 x 4800 dots per inch. This dithering process means that it is worth experimenting by printing at a range of different resolutions to see what you can safely print as the dots blur the individual pixels. If a photograph is framed on a wall the pixels

➡ *9 MP compacts can produce 44 x 33 cm (17 x 13 in) prints at 200 dpi.*

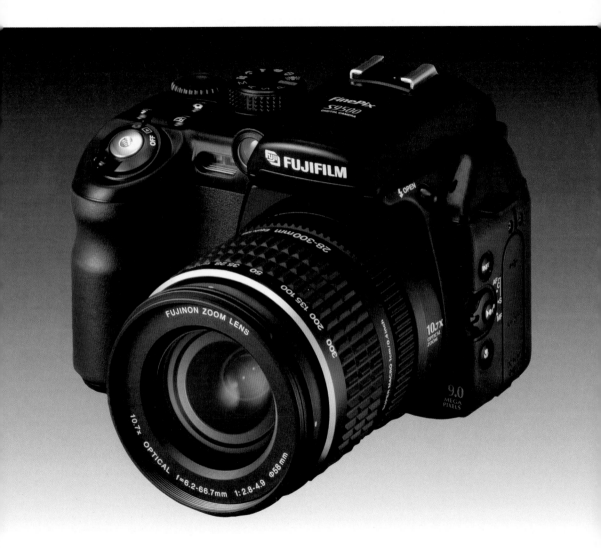

may not be visible to the naked eye owing to the increased viewing distance, whereas in a photo album they may be more obvious.

Changing the Image Size

You can change the image size and resolution in Photoshop through the Image Size options (or Resize options in Paint Shop Pro). Before you make any adjustments to the image size make sure that Resampling is turned off, and check the Constrain Proportions box to make sure that you don't accidentally adjust the scope of the image. Using either 'cm' or 'inches' (depending on your preference) enter the desired width you want to print in the Document Size box. You will see the Resolution change – if it falls under 200 ppi the print size is too large and for good-quality prints it is advisable to enter a smaller print size. Once you are happy with your image size, tick the Resample Image box and enter your desired resolution. If you are reducing the size of the picture you will see the Pixel Dimensions change and the image size decrease. This is because by resampling you are adjusting the pixel make-up of the entire image and as you reduce the file size pixels are deleted. Be careful if you are resampling to create a larger image size, the quality can be greatly reduced.

⬆ *A 2 MP camera.* ➡ *To enlarge or reduce the size of your image, make sure the Resample Image box is ticked.*

Image Size

Pixel Dimensions: 4.21M

Width: 1400 pixels

Height: 1050 pixels

OK

Cancel

Auto...

Document Size:

Width: 17.78 cm

Height: 13.34 cm

Resolution: 200 pixels/inch

☑ Scale Styles
☑ Constrain Proportions
☑ Resample Image: Bicubic

Understanding the Print Options

The easiest way to check how your print looks on the page is to preview it. With this useful tool you can see the position and size of your photo on the page before it is printed, ensuring you can make any necessary adjustments before you commit to print.

Positioning Your Image

In Photoshop select Print with Preview from the main menu and your photo will be displayed in a white box on the left of the page. By default the box Center Image is ticked, which aligns your photo to the centre. To change its position uncheck the box and drag the photo to its new location.

Page Orientation

Your preview will let you know if the page orientation is incorrect – if you print a landscape photograph in portrait format you will lose half your image and waste paper. This is adjustable in most image editors through the page setup command or in Photoshop by clicking the Page Setup button.

Print Sizes

Printers can produce prints at a range of different sizes – 15 x 10 cm (6 x 4 in) and 18 x 13 cm (7 x 5 in) are fairly standard, but you can also print up to A4 and produce panoramas. Photoshop retains previous printer settings, so if you are printing out on a different paper size, ensure the Scale is set to 100 per cent, remembering to later select a new paper size before printing. If you want the print to fill the page tick Scale to Fit Media.

➡ *Always print using the correct paper orientation for your image.*

If you haven't chosen a print size in Photoshop you can change the size of your print when you are previewing it by adjusting the Scale, Height and Width percentages in the Scaled Print Size box. However, any adjustments you make may impact upon filter effects and because the preview screen is very small, it is more accurate to make the adjustments to the size of the picture in Photoshop before previewing.

Paper Orientation

Before you begin to print, check the paper is positioned correctly - you may need to refer to the manual to see whether it should be face up or face down. To the eye gloss and matt sides of paper can look very similar and it is easy to print on the wrong side.

Ink Levels

Check the status of ink in your printer, otherwise your print may lack colour tones (a warning usually appears on the LCD screen of your printer). However, after the warning appears you should be able to keep printing, depending on the model of printer.

⬆ ➡ *Check both that the image fits the page (using the Print Preview function) and that the paper is inserted correctly.*

Types of Media

It is important to choose the right paper for your prints so that you can show them at their best. It can be difficult knowing which to choose with so many different paper types and brands on the market, and the paper you choose will vary depending on what you are using your prints for.

Paper Surfaces

You need to consider the type of surface you want your paper to have, from matt to satin (which is slightly shinier), or semi- and high-gloss finishes. The majority of processing labs use gloss, although a matt printing is often an option. The glossier the finish the more reflective it is. Bright colours benefit from shinier, glossy paper, while for more subtle photos a flatter matt surface is effective.

Paper Weight

The weight of the paper is important - the more grams per square meter (gsm), the heavier - and more expensive - the paper. For text documents, 80 gsm is suitable, while photographic prints need a minimum weight of 230 gsm.

⬆ *Experiment with different photo papers to find one that suits your photography.* ➡ *A gloss paper is very shiny.*

Available Colours

Photo paper is not just white; it comes in a selection of shades – such as pearl and oyster – each of which produces different results. The whiter the paper, the brighter the colour results.

Matching Printers with Papers

Dye-sublimation printers require special types of paper and inkjet printers may not be able to print on all types of glossy paper, so it is important that you check your printer manual or the company website to see what paper is compatible, otherwise it could cause print problems and any serious error may invalidate the guarantee. Major printer manufacturers, such as Canon, HP and Epson, recommend printing on own-brand paper because the ink and paper are designed together to produce optimum results on the page. However the photo paper market is increasingly competitive and brands such as Tetenal, Ilford and Perma Jet are well respected – once again check to see what paper your printer is compatible with (normally shown on a leaflet inside paper packets or online at the paper manufacturer's website) before investing.

If you are unsure about what paper to use, many paper manufactures produce sample packs containing a selection of different paper types, which is an advisable investment. You can also print on to stickers, postcards and CD covers, as well as canvas or fine-art paper, but these can be expensive so try to avoid wasting paper with errors, and always produce a test print first.

⬆ *Some printers enable you to print directly on to CD covers.* ➡ *Manufacturers like HP want you to use their paper.*

Get it Done Elsewhere

If you don't have the time or inclination to print, or you do not want to spend money on a printer, you can send your photographs to a third party to print them.

Using a Lab

High street printing is straightforward, although it varies from store to store. Self-service kiosks are becoming increasingly popular; you use these by inserting your memory card into a slot, and selecting the photos you want to print and the desired quantity by pressing icons on the screen. It is a very simple process and you can always ask a shop assistant for help. Once completed, the machine will give you a receipt that you can take to the cashier, or you can give your memory card to the shop assistant and they will process the order for you.

The price of printing on the high street changes all the time, with the supermarkets edging out photographic stores in terms of value, but both are cheaper than home printing. In common with online photo labs; the more prints you buy the cheaper the price per print tends to be.

One of the major disadvantages of using an external printing service is that you never know what the results will be, so the standard of prints may vary.

⬆ *Some labs can put your images on mugs.* ➡ *Kodak print kiosks allow you to insert your memory card and select your prints.*

Uploading to Online Labs

The advantage of buying online is that you can order prints at home and they will be delivered directly to you. Delivery times can range from a day to a week – most companies offer standard delivery, which can be free or cost up to £5.

Print prices are generally cheaper online because the overheads of the online companies are low. Shop around to find the best deal because many retailers offer introductory free prints for registering and more for referring a friend.

To save time before you upload your images you should save your photographs as JPEGs (this is the commonly accepted file format because TIFF files take too long to upload) and place them all into one folder.

You will need to register at the website and provide your email for correspondence and your postal address for delivery. There are two methods of uploading images. Sites such as Jessops and Bonusprint need you to download a small piece of software, which you can use to transfer your pictures on to the site, whereas PhotoBox requires you to upload the photos directly to the site.

Ordering prints is designed to be easy and is usually a step-by-step process. You choose the number of prints, size and finish, and at the final stage you enter your credit or debit card details. Confirmation is then sent to your email address.

Some websites provide you with free memory storage for your pictures (which is often unlimited) enabling you to return and order more prints without having to upload the images again.

➡ *To use this online printing service, you need to download software.*

JESSOPS.com

NO.1 IN PHOTOGRAPHY

 COMPARE PRODUCTS / COMPILE WISHLIST

 TROLLEY

Items 0
Value £ 0.00
View Trolley

HOME | MEMBERS' AREA | USED EQUIPMENT | STOREFINDER | ABOUT US | CONTACT US | HELP

HINTS ● GO!

Cameras
Digital
Camcorder
Camera Phones

Accessories
Bags and Cases
Batteries
Binoculars
Books
Computers
Darkroom
Digital Paper
Exposure Meters
Film
Filters
Flash
Ink Cartridges
Lenses
Memory Cards
Printers
Projection/Viewer
Scanners
Scopes
Storage/Mounting
Studio Lighting
Tripods/Supports

Clearance Items
Instruction Books

Jessops Photo Express - Prints via the Internet

back to main page

JESSOPS
photoexpress

Get your images printed onto photographic paper - the easy way.

Your own images printed on the very latest Fuji Frontier digital printers on to Fuji Crystal Archive paper. The same high quality process as used in our Diamond Laser service!

Order via your PC - your prints will be posted to your home.

Scanning at Home

You can convert photographs and negatives into digital files using a scanner, which is why many digital photographers choose to include a scanner in their digital darkroom set-up. Whether it is restoring prints or functioning as a camera, scanners have a multitude of uses.

Why Invest in a Scanner?

The majority of households across the country will have boxes of photographs collected over the years, waiting for someone to sort them and put them in an album. A flood or a fire could destroy hundreds of pictures representing precious memories that have been collected over the years. One way to avoid this is to invest in a scanner – a device that converts your prints or negatives to digital files through a process called digitizing. This process converts information about different light values from the picture or transparency into pixels on your computer.

Types of Scanner

There are two types of scanners, and the device you need depends on what you intend to scan. Film

⬆ *Don't let old photos be forgotten.* ➡ *A scanner and a computer are all you need for a digital darkroom.*

scanners scan transparencies, including negatives and slides, and flatbed scanners scan photographs and sometimes transparencies (with an adaptor). Once a photo or negative has been digitized you can apply the same editing techniques that you would use on a digital photograph: correcting uneven horizons, repairing colour casts, cloning out unwanted elements and removing red eye. You can also use scanners to restore black and white photographs, particularly those that have been damaged and scratched.

Once You Have Scanned

Scanning old photographs makes it easy to share your pictures, by attaching the file to an email or incorporating them into montages and picture books for friends and relatives. Crucially you can save the files on to a CD or portable storage device to create a back-up and preserve it for future generations.

Scanning Companies

There are companies that will scan photographs for you, but it is easier (and cheaper) to do it yourself. Scanning at home is very convenient, you can set up the device next to your computer and printer and with some practice you will be creating scans in minutes.

⬆ *Some companies will scan film as well as prints.* ➡ *Create back-ups of your old photos by scanning them.*

Flatbed Scanning

Flatbed scanners are used primarily for scanning photographs, but many include a transparency adaptor so that you can scan negatives, slides and photos. These hybrid devices have become increasingly superior over the last few years, making them a good option for anyone who wants to scan transparencies and photographs. Flatbed scanners tend to be more affordable than their film counterparts - it is possible to get a rudimentary A4 scanner for under £50, which will be adequate for occasional use.

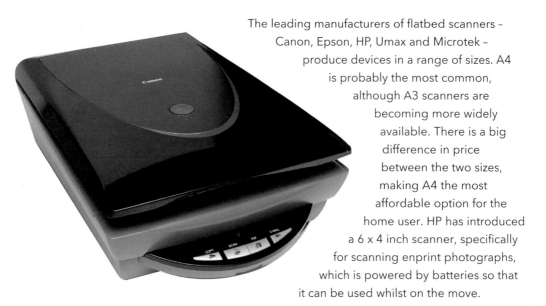

The leading manufacturers of flatbed scanners – Canon, Epson, HP, Umax and Microtek – produce devices in a range of sizes. A4 is probably the most common, although A3 scanners are becoming more widely available. There is a big difference in price between the two sizes, making A4 the most affordable option for the home user. HP has introduced a 6 x 4 inch scanner, specifically for scanning enprint photographs, which is powered by batteries so that it can be used whilst on the move.

↑ *The Canon Canoscan 9950F is aimed at slightly more advanced users.* ⇒ *Lift the lid and position the photo on the glass bed.*

Preparing the Scanner

Flatbed scanners work by shining light on to the surface of the photo, where it is reflected and caught by the sensor (CCD, or Charge-Coupled Device). Before you begin to make a scan, turn the device on for a few minutes to allow it to warm up. Care needs to be taken to ensure the photo is dust-free and that the glass plate is clean, otherwise particles of dirt may be visible in the scan.

Making a Scan

Open the plastic hood and position the photo on the glass plate. Make sure it is aligned carefully, or you may have to rotate the photo using your scanning software, which can lead to a reduction in picture quality. Photographs are scanned on one side, which means it doesn't matter if you perform the scan with the lid open. The easiest way to make a scan is to hit the Quick Scan button (located on the front of many new scanners) although for a greater degree of control you can perform the scan using the software on your computer. You will hear a whirring noise as a sensor positioned inside moves up and down making the scan.

⬆ *This flatbed can scan photos and 35 mm negatives.* ➡ *A vertical design takes up less space on your desk.*

Getting Technical

Pixels & Resolution

Digital photographs are made up of small squares of colour called pixels, and the number of these in an image is the resolution. These pixels translate to your computer monitor.

Camera Resolution & Monitor Resolution

Camera resolution is decided by the number of pixels on the sensor. A typical 2 million pixel picture will be made up of 1,600 x 1,200 pixels - in other words, 1,600 pixels across and 1,200 pixels down. If this is then shown on a monitor with a similar resolution at 100 per cent view, the image will match the display pixel for pixel and fill the entire screen. A larger resolution image of 4 million pixels (2,304 x 1,712 pixels) will be too big for the screen, so only part of the image will be shown. It is generally recommended to set

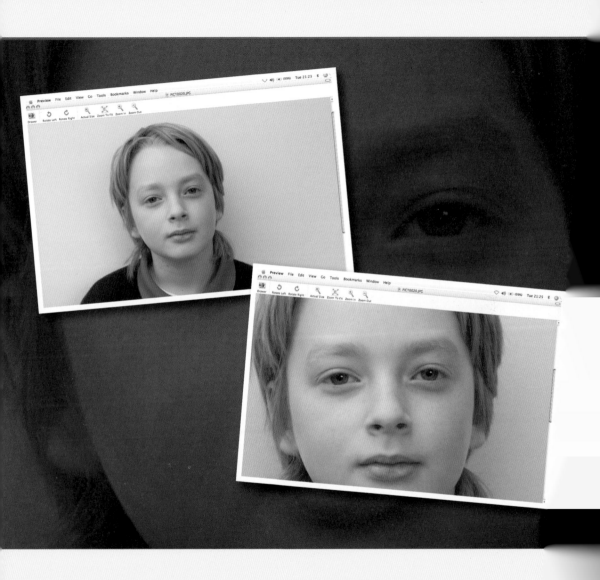

computer monitors display images at 72 ppi, or pixels per inch. This further refines the screen size, by indicating exactly how many pixels are in a single inch of the computer screen. Using this knowledge we can then work out how big an image will appear on screen. If 72 pixels equal 1 inch, and an image size is 1,600 x 1,200 pixels, then the screen size of the image will be 1,600 divided by 72 and 1,200 divided by 72. Thus the image will be 22.2 in long by 16.7 in wide.

This is an important aspect to remember, especially if you are preparing images for websites or any other screen-based viewing. A 22 x 16 in image will not fit on most computer screens, so the image will need to be altered to a viewing size that will display well on the majority of monitors.

DPI or PPI

Printing images can cause confusion. Rather than pixels, printers use dots of ink, and the print resolution is referred to as dpi, or dots per inch. The simple rule to remember is ppi for screen, dpi for print. The same rule is used for estimating the final print size, but this time divide the number of pixels by 300, so our 1,600 x 1,200 pixel image becomes a 5 x 4 print. You divide by 300 because the best results are usually obtained at 300 ppi, although the human eye can rarely see beyond 200 ppi.

⬆ *A close-up of the dots of ink used by a printer.* ➡ *Remember that printers use dpi instead of ppi.*

Digital Colour

Colour is one of the biggest issues in digital imaging. From replicating the colours of a scene with your camera to displaying the colour on a computer monitor and printing your images, colour can be complicated. It is now easier than ever, though, thanks to digital technology.

Camera Colour

The pixels on a camera sensor are covered by colour filters in a red, green and blue array. Each colour has 256 tonal variations from lightest to darkest, resulting in up to 16.7 million (256 x 256 x 256) colours.

Most digital cameras do not accurately reflect real world colours. Research shows that consumers prefer more vivid colours in their images, with more saturation. This is partly due to memory – we remember colours more vividly than they really are – and also because we prefer to see deep blue skies, healthy skin and bright, bold colours, which may not be a true representation of reality. Cameras have been developed to cater for this.

Colour Profiles

Colour profiles are standards that allow different devices to match a particular colour. Each colour in a single pixel is recorded as binary data, described by a string of up to 24 numbers. Every device that uses that image, be it a camera, PC or printer, needs to be able to understand those numbers and replicate it accurately. So a standard colour

➡ *It can be hard to reproduce colours in a printed image.*

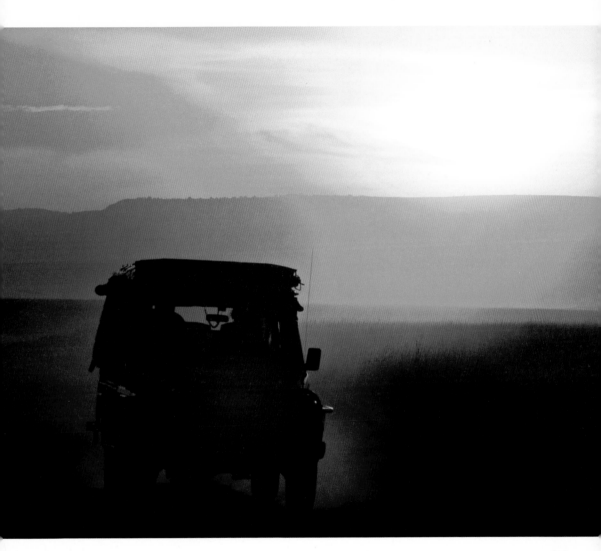

space (the extent and limit of the colours that can be represented) is used that all devices understand. There are two common colour spaces used in digital imaging.

sRGB

sRGB is the most common and simple profile to use, and most compact cameras will only offer this option. It can reproduce most colours, but by no means all that are displayed on a monitor. Use sRGB for images that will be viewed unretouched. While using a restricted colour space may seem like throwing a lot of useful data away, printers cannot always display those colours captured and manipulated in other colour spaces. In effect, sRGB saves you from throwing away data at a later stage.

AdobeRGB

This is a second option in more sophisticated digital colours. It has a wider range of colours than sRGB, which means a broader range of colours can be recorded and also gives more scope when you are manipulating the exposure and colour of an image. Professional printers use AdobeRGB and it is the preferred choice for images that need to be retouched on a computer.

Colour Matching

Printed pictures can often look very different from what is seen on a monitor. This is due to the different nature of the two mediums. Monitors output in transmissive light – the light comes from behind the image into the eye. Images therefore tend to look brighter and more colourful. Prints are viewed via reflective light – the light is bounced from the print to the eye, so they look darker unless you view them under a very bright light. In addition, the inks used may not replicate the brighter colours of a monitor, although modern printers and inks are developing all the time.

➡ *The technology needed to reproduce colour accurately is improving all the time.*

File Formats

Cameras take images in a number of file formats. For a compact camera this may be the commonly used JPEG, while for more sophisticated cameras other formats such as RAW and TIFF are options.

image.JPG
2,048 x 1,536

JPEG

By far the most common and popular format, JPEGs are processed images that are compressed into smaller saved files. When opened, the file returns to its original size. Because of their small size JPEGs can be stored quickly, meaning that your camera is faster to operate, and more images can be stored on your memory card and hard drive. However, the compression system can sometimes cause defects in your images. Compression means using less storage space, which means less image data. Consequently JPEG is known as a 'lossy' format as it throws away some of the image information (see pages 272-75).

RAW

forest spring.dcr

RAW

The RAW file is essentially a digital negative, the data that comes immediately from the camera, bypassing the camera's processor (which adds its own parameters and algorithms to the file) and retaining all the original information. Many photographers prefer to add these processing changes themselves for maximum artistic or technical effect. RAW files vary between different makes and models of camera, and special software is needed to open and use the files before saving.

➡ Camera using a RAW file format.

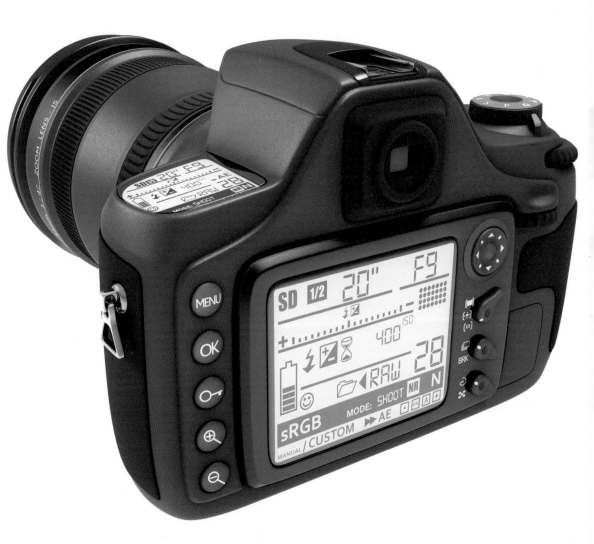

TIFF

Once the most popular format, a TIFF file is processed by the camera but not usually compressed, often resulting in very large files. This makes the camera slow to work with because of the amount of data that needs to be processed, and memory will be limited. TIFF is a popular format in which to save images on a computer, however, particularly if you choose the uncompressed option. This means that all the data left by the software is present and the image quality will not be reduced. However the large file size does mean that fewer images can be stored on your hard drive or CD.

DNG

DNG is a fairly new format developed by Adobe, to overcome the archival problems of RAW files and the danger that files from older cameras will be unsupported by future software packages. The DNG file is converted from the original file with no loss of information, but Adobe has promised to continue supporting the file type indefinitely.

PSD

If you use Photoshop and make adjustments to the images using layers or other means, you should save any work in progress as a PSD. This saves the state of the file and layers, allowing you to go back to the image and make corrections and changes without destroying the original image.

➡ *If you have a lot of TIFF files on your camera you'll need lots of storage solutions.*

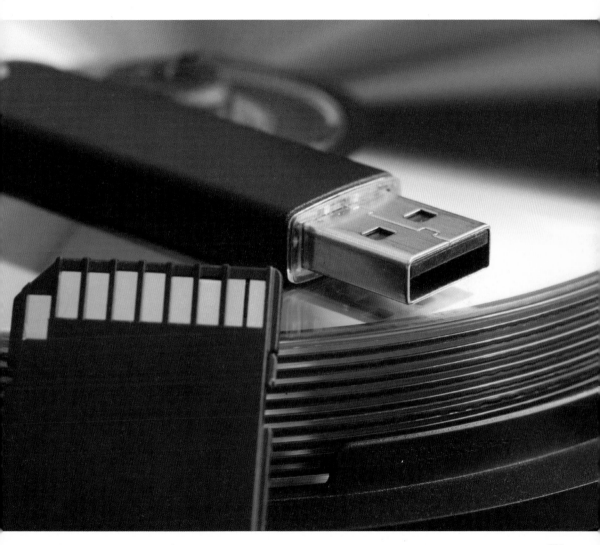

Compression

Picture files can be very large, so it is often necessary to compress the file to make it smaller. This involves a selective discarding of 'unnecessary' image information. This will increase the speed of saving and loading the image, as well as allowing more space on your memory card and hard drive.

Image files are either stored as compressed or uncompressed. JPEGs are compressed files that are smaller when stored than they are when opened. For example, a 3 megapixel camera will produce a maximum file size of 9 megabytes (MB) of binary data. This means that when you open your picture on the computer it uses 9 MB of memory.

If you look at the size of the unopened file in your pictures folder though, it will probably be about 1 MB. That is because the file is compressed. An uncompressed file will show a file size of 9 MB both when opened and when closed.

Lossy Compression
JPEG compression is referred to as a 'lossy' compression. This means that during the compression process, some information is

⬆ ➡ Different compression rates on a computer.

removed from the original file in order for the file to be saved at a smaller size. The data removed is often areas of flat colour, for example a flattish sky. An algorithm in the processor works out that all of the surrounding pixels in the sky are largely the same colour and discards as many of them as it can (for the level of compression required), leaving a note in the file that it has done so and where. When the file is reopened the computer sees the message and replaces the missing pixels from the information that the compression algorithm left there.

While the JPEG algorithm is sophisticated, the human eye and brain combination is more so. You may notice faint blocks, obvious to the eye even though they may be only marginally different colour shades. Similarly, where large blocks of colour meet, the junction between them may look jagged. The effect of this differs depending on the compression ratio used, but it may spoil your picture.

Compression Ratios

Most cameras offer a choice of three compression ratios. On a digital camera this is often found in the Quality subheading in the main menu. Often this will be depicted as a set of stars, or by high, medium and low options. Whenever possible chose the highest quality. The lower the quality, the more your picture will be compressed, with more data discarded. This means that you can fit more pictures on your memory card, but the likelihood of picture-spoiling problems increases.

File Sizes

The nature of the scene in an image to be compressed will also have a bearing on the amount of compression that can be applied. Images with lots of fine detail will not compress as well as more simple shots do.

➡ *Decreasing compression rates will affect the quality of the image.*

Basic Hardware Needs

You do not necessarily need a computer to begin digital photography, but your experience will be greatly enhanced if you have one. As a general rule, you should buy the fastest computer you can afford. With cameras getting more and more advanced, it will save a great deal of time and frustration. There are also a few extras you may like to invest in.

Computer

There are two basic types of computer: Apple Macintosh or a PC (personal computer – for more on this, see pages 284–87). Both need to run Windows, Linux or Unix software (see pages 280–83). The important things to look for are memory, both RAM and ROM, and processing speed. The higher these are the better – you will be able to work with your photographs more quickly and have the capacity to store more images.

Monitor

Most computers now have flat screens, which have recently improved in quality. The bigger screen you can afford the better – it is easier on the eye and is invaluable for seeing detail in your images. It also allows more space for toolbars when using picture-editing software.

Printers

There are a huge variety of printers available. Think about the size of image you will be making, and whether you want to print images at a larger size than A4. You may already have a printer that came with your PC – find out if it can print photographs, but

⇒ *Good-quality flat screen monitors reduce the strain on your eyes.*

remember that cheaper printers will produce lower quality images.

Photo Paper

If printing your images at home, it really is worth investing in good quality photographic paper. Your images will look clearer, sharper and last much longer.

CD/DVD Drive

Digital photography has meant that you no longer need to have piles of photographs gathering dust as they wait to be put in albums. Instead you can store thousands of digital images on a disk. Not only does it save on space, but having back-ups of your photographs on disk provides peace of mind – if your computer broke down or was stolen, you would not lose all your images. Most computers come with a CD/DVD drive with which to view the contents of a disk, but it is also very useful to have a CD/DVD burner. This is a device that enables you to transfer data, including picture files, to a disk. Saving images to a CD or DVD will also free up space on your computer's hard drive. This is very useful, as the ease of digital photography means that you will quickly build up a huge library of images.

⬆ *If you want to print photos, buy a good printer.* ➡ *A CD/DVD burner is a useful accessory.*

Operating Software

When you first buy a computer you need to know which operating system it uses, and this may well influence your choice. By far the most common system is Microsoft Windows, but there are other options available.

Microsoft Windows

There are several different versions of Microsoft Windows available. The latest is Windows 7, though many people use its predecessor Windows Vista and even the version before that, Windows XP.

The chief advantage of Windows is its ubiquity. Over 90% of all computers in the world run on Windows. There is an enormous range of accompanying software and Windows-compatible hardware available from third party manufacturers, and good support. On the downside, Microsoft constantly have to update the system to fix bugs, security flaws and so on, which can lead to hackers, crashes and worse. Some budget netbooks use a scaled-down version of Windows 7 or XP.

⬆ *Manufacturers need to guard against viruses.* ➡ *A Microsoft Windows desktop looks like this.*

Mac OS X

While Windows PCs were originally built for business use Apple Macs were designed for graphics from the outset, which is why they have become the computer of choice for the majority of the world's designers, photographers and other visual arts professionals. Although Windows has now largely caught up many people still prefer the Mac for its styling, stability, reliability, ease of use and the quality of the bundled iLife software suite.

Unix/Linux

A third option, growing in popularity but still mainly suitable for advanced computer users, is a Unix-based system. Unix first started life in the 1970s at AT&T and was developed in different directions by many IT companies. Since 1995 however, there has been a single Unix Specification. Apple's OS X is a Unix variant, but there is also an open

source operating system called Linux which has become increasingly popular with power users interested in looking 'under the bonnet'. Although some Unix or Linux variants are not especially user-friendly, they have the advantage of being much cheaper than Windows and being open source – where a world-wide community looks for faults and suggests solutions. They are also generally stable and fast. If none of the above makes much sense to you, you should stick to Windows for a PC and OS X for a Mac.

⬆ *Shop around before you decide what sort of computer to buy.* ➡ *A typical Mac OS X desktop.*

Mac or PC?

Whether you are already a keen photographer wanting to switch to digital photography, or a beginner who wants to get the best out of their photographs, you may find that buying a computer or upgrading your existing machine is well worth the expense.

There are two main choices when buying a computer: Mac (Apple Macintosh) or PC. Each system has its advantages and disadvantages, and you need to carefully weigh the pros and cons of both. If it is your first computer, then there will be a steep learning curve as you learn not only about digital photography, but also how to use a computer.

The term PC stands for personal computer, and is slightly misleading in the Mac/PC debate. An Apple computer is still a PC – in fact the range has for a long time used the PowerPC name, but for the sake of clarification and to conform to modern usage, a PC is a computer that operates using the Microsoft Windows family of operating systems.

Mac

Apple Macintosh computers were one of the earliest desktop computers, and Apple were the first consumer manufacturers to adopt and develop the Graphical User Interface (GUI) invented by Rank Xerox, making computers easy to operate for non-programmers. In fact, Apple was the first company to use the 'window' system commercially as a way to open folders and software.

➡ *Apple Macintosh computers are renowned for their cutting-edge design.*

Apple's real breakthrough came in the early days of desktop publishing, as designers, printers and other creative or media companies began to switch to computers in the 1980s. At the time, Apple computers were ahead in the ability to process large graphic files. Today Apple continues to appeal to creative-minded people, including photographers, due to the ease of use of the operating system, the wide range of graphic software and the groundbreaking design of the computers themselves.

PC

Microsoft Windows is the operating system of choice for the vast majority of computer users, especially in small offices and the home. Part of Microsoft's winning strategy has been its licensing policy. Rather than making computers, Microsoft concentrated on the software to make them work, with the operating system being included free with most new computers.

Microsoft has often been criticized for its software stability, but recent releases, such as Vista and the new Windows 7, offer better performance. The fact also remains that most people use Windows and it is more compatible with peripherals and software.

Which One is For You?

Ten years ago a Mac was the only choice for photography, but the Windows operating system is now a genuine contender and a PC tends to suit most people. Ultimately, choosing a computer is down to personal choice and how computer-literate you are.

⬆ *You can try out different computer models in-store.* ➡ *A typical PC set-up.*

Memory

There are two types of computer memory that you need to consider before buying or upgrading: RAM and the hard drive. In both cases, the more the better. But what is the difference and how much should you have?

RAM

RAM stands for Random Access Memory and is the computer's short term memory. RAM is used along with the processor to perform the complex mathematical calculations that are at the heart of computer operation.

Most modern computers should have at least 2 GB of RAM. Adding more will increase the efficiency of your machine and make it work faster. The speed of RAM depends on the size of the file you are working with, the application you are working in and the action you are performing. In imaging, using layers rapidly increases the file size, and the larger the file size, the more likely you are to run out of RAM. This means that the operations you perform will take longer, sometimes several minutes or even several hours. Alternatively the computer might freeze up altogether if the RAM is full and cannot cope with the task it is trying to perform.

RAM is also used up by other applications you may be accessing at the same time, notably the operating system, but also playing music through your computer, downloading files from the internet, etc., all of which will slow down your machine. Try to use memory more efficiently by quitting applications when you are not using them or flattening image files when you are happy with any work you have done.

➡ *The size column shows the relative memory each type of file uses.*

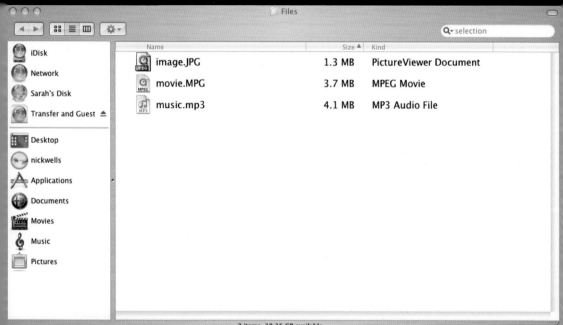

Files

Name	Size ▲	Kind
image.JPG	1.3 MB	PictureViewer Document
movie.MPG	3.7 MB	MPEG Movie
music.mp3	4.1 MB	MP3 Audio File

iDisk

Network

Sarah's Disk

Transfer and Guest ⏏

Desktop

nickwells

Applications

Documents

Movies

Music

Pictures

3 items, 38.35 GB available

Always bear in mind that graphics and multimedia files such as videos and music use a lot of memory.

The Hard Drive

The hard drive is essentially your storage area. Every bit of data that you save on your computer is stored on the hard drive, from the operating system and the applications you use to your files, including your pictures. This has caused many problems for computer manufacturers – as operating systems and software get more complex, they use more space on the hard drive, and file sizes are also increasing. In digital photography, for instance, as cameras get more powerful and provide more pixels per picture, the need for more memory to store them is constantly increasing. Large video files, music files and other multimedia files also increase the need for storage space. A few years ago hard drive memory capacity was small and disks were used for extra storage, but hard drives are now getting bigger all the time – so much like RAM, the more you have, the better.

⬆ ⮕ *External hard drives can increase your memory capacity.*

Processor Speed

The first home computers had processors with a speed cycle of 8 MHz – in other words, they were controlled by a clock that clicked to the next operation in 1/8,000,000 of a second. They had very little RAM and the instruction sets (permanently recorded mini-processes) were very simple. Their graphics were monochrome and unsophisticated.

A quarter of a century later and computers have processors that have 3.6 GHz clocks (i.e. their clock cycles every 1/3,600,000,000 of a second). Ironically, this 450 times increase in clock speed doesn't always mean that computers are any faster, as file sizes have more than kept up with the increase in computing speed. Software has also increased in size, needing more memory and more chip speed.

The CPU

The Central Processing Unit (CPU) is the real thinking part of the computer. This is where the complex mathematical equations that are behind every change to your images are performed. Not content with having increasingly faster processors, manufacturers are now putting more than one processor into their computers. Computers are now available with dual or quad processors that further boost the speed by parallel processing or multi-threading, allowing several complex operations to be performed at the same time.

Although many years ago it was thought that processor speeds would continue to rise, the physics has quickly caught up with the reality that faster speeds are not possible due to overheating. A 3.2 GHz processor working flat out can safely run between 40°C and

➡ *Computer processors are becoming more sophisticated all the time.*

60°C, though can rise as high as 80°C or more. Obviously clever cooling technologies are devised to keep the apparent temperatures much lower, though laptops can often feel hotter when running at near-maximum CPU capacity.

Recently the world record of a CPU running over the 7 GHz barrier was broken – but this was only possible in a lab with the use of liquid helium (which 'boils' at -268.9°C) as a coolant.

Graphics and Video Cards

Along with the processor, RAM and hard drive, digital imaging requires a fast video or graphics card. These are computer components dedicated to video and image rendering, i.e. converting the data for each pixel of an image and scaling the image to show the magnification you have chosen on your monitor. Each time you move your image the graphics card has to 're-draw' it.

The increase in 3D rendering for games, modelling programmes, 3D TV and the rise in high definition output has increased the need for even faster video processing. Some graphics cards can easily be upgraded while others are built into the computer's motherboard and cannot be upgraded. Like other components, for digital imaging buy the fastest (i.e. the most expensive) you can afford. Otherwise the computer may be performing your manipulations in the blink of an eye, but it will take 30 seconds for you to see the results on screen. It doesn't sound like much, but in practice can be very frustrating.

Connections

After you have taken a picture with your camera you need to transfer it to your computer, and then pass that picture to your printer. In order to connect these different devices you will need cables, and there are several options.

Serial Cables

Serial cables and SCSI (Small Computer Systems Interface) were once the preferred choice of connections for computers, but times have changed and there is now a new series of interfaces that most peripherals use. Each has its own set of uses but the main thing to check before buying a peripheral of any kind is that your computer can actually connect to it.

USB

The first replacement for SCSI was the USB (Universal Serial Bus) connection – now the most common way of connecting devices to a computer. Many cameras still use USB 1.1, which offers a data transfer rate of 12 megabits per second. This is slower than SCSI, but there are many advantages to USB. Every PC now made has a USB port, making it truly universal. USB cables are also 'hot swappable', meaning that you can swap devices without turning off the computer. In addition, USB cables can, for low-drain devices, supply power to peripherals.

In 2001 the standard was upgraded to USB 2.0 and many more computers, printers, scanners and cameras now offer faster data transfer rates. It is worth bearing in mind

➡ *USB cables are used with all sorts of devices including digital cameras.*

however that USB now comes in a number of different types, namely USB, Hi-Speed USB and Full-Speed USB 2.0. Mice and keyboards use USB and only require a transfer rate of 1.5 Mbits (1.5 million bits of data per second). For non-keyboard/mice products USB offers the Full-Speed option (i.e. 12 Mbits per second), while Hi-Speed has a possible maximum transfer rate of 480 Mbits per second. These are theoretical maximums, however, and you will rarely get that high a rate of transfer.

USB 2.0 and 1.1 devices are compatible with USB 2.0 and 1.1 computers, but the slower transfer rate will apply where two standards are mixed. An even faster USB 3.0 standard has recently been launched, but as yet there are few devices that feature it.

Wi-Fi and Bluetooth

It is not always desirable to have cables cluttering up a desk, and wireless standards are becoming increasingly popular. The two main types of wireless communication are Wi-Fi and Bluetooth. Only a couple of cameras from Sony have so far used Bluetooth, but many camera phones use it as standard to transfer images between phones, computers and printers. This suits the small files produced by most phones, but the transfer rate is unsuitable for larger image files.

Wi-Fi (known as Airport on Apple Macs) on the other hand looks to be the future for cameras, with models from Kodak, Nikon and Canon all taking advantage of the new technology. The Kodak Easyshare One, for instance, transfers files across your home wireless network and also across the internet via Wi-Fi hotspots. This allows you to upload pictures directly to the Kodak website or email pictures to family and friends.

➡ *Many people use Bluetooth technology on their mobile phones.*

Archiving: **Portable Storage Solutions**

Unfortunately computer errors do occur, and the only way to cope with this happening is to create back-up copies of your photographs by burning them on to CD or transferring them on to a portable storage device, which you can keep separate from your computer.

Burning a CD

You can burn your photographs onto conventional CD-R's that can only be used once, or CD-RW's that you can use more than once. If you are backing up your digital photographs you probably want to keep them forever, so CD-Rs are probably the best small-scale solution and are ideal for storing JPEGs. DVD is becoming an increasingly popular format for burning images, because it provides the advantage of 4.75 GB of storage per disk in contrast to the 700 MB offered by a CD. While DVDs will take longer to burn, they allow much more storage, particularly if you have saved images as TIFFs or kept RAW files.

To burn a CD use the software supplied with the burner, which is usually straightforward, or invest in a dedicated burning program. In Windows XP you can copy files without opening specific burning software

⬆ *External CD burners are available.* ➡ *DVDs are another storage option.*

simply by clicking Copy to CD in the Picture Tasks menu (if your computer has a burner). It is often a good idea to burn two copies – one for reference and one for storage, just in case something happens to one set of disks.

One alternative is to create a slideshow of your images complete with transitions, sound effects and captions. This is useful when you have a selection of images based around a theme, such as a family holiday or Christmas. There are a range of programs for this, varying in price, including Magix CD and DVD or Roxio Easy CD and DVD Creator. See pages 210–13 for more on this.

Hard Disk Drives & Storage Devices

If you do not want to burn your images on to CD you can store them on an external hard drive, such as those from LaCie or SmartDisk. These connect to your PC via a USB cable and mount on your PC desktop. Simply drag and drop the files you wish to save. Alternatively, invest in a portable storage device. The Nikon Coolwalker and Elio PhotoJukebox are hard drives with capacities ranging from 20 GB to 80 GB. Copy photographs on to them using a USB cable or through a memory card slot. Recently portable storage devices have also become viewing devices: the Epson P-2000 has a 40 GB hard drive and features a 9.7 cm (3.8 in) colour screen, which is a great way of sharing your digital photographs. Bear in mind, though, that if your hard drive fails you will lose all your photographs unless you also copy them to CD or DVD.

⬆ *The Nikon Coolwalker provides 30 GB of storage space.* ➡ *You can store up to 40 GB of images on the Epson P-2000.*

Getting to Grips with Image Editing

Image editing is great fun and can be very simple to do, so don't let yourself be put off by the array of jargon, tools, palettes and commands. This next section will guide you through the basics of how to get the most from your digital photographs by using image-editing software on your home computer.

Once you have taken your picture and successfully downloaded it on to your PC, you may be ready to print or share it on the Internet. However, you may wish to improve or enhance your photograph. You might not have held the camera straight and the horizon is slanted, or your subject may have red eye. Whatever your problems are, your image-editing software will help you to correct them with only a few clicks of the mouse.

Software Packages

There are a great many editing software packages available on the market today. You will sometimes find simple or cut-down versions bundled with your camera, scanner or PC. They can be a good starting point for your basic editing, and many of the simple techniques you would like to use can generally be achieved with most of these packages.

⬆ *Adobe Photoshop Elements.* ➡ *Use image-editing software to correct basic errors such as straightening a crooked horizon.*

But if you are serious about creating quality and controlled results, it may be worth investing in a home package such as Adobe Photoshop Elements or Corel Paint Shop Pro. These home-editing programs offer more sophisticated functions and tools with a complete photo-management system.

Set Up

Before you buy your software, it is a good idea to check out your PC's RAM and hard drive space. A minimum of 256 MB of RAM is normally required and 800 MB of available free hard drive space. You will also need a CD ROM drive and, for most applications, at least a Pentium III processor. The software will become more stable and run faster if you have more than the minimum requirements of processing power. You will also need a monitor that can display at least 1024 x 768 pixels on screen in 16-bit colour.

After Installation

You should also spend some time assessing your work place. It is important to try to keep the monitor faced away from direct window light because the reflections may distract you. Place your PC in an internal corner with the monitor facing the wall, and try not to have an overhead light casting shadows across the screen. Any unwanted extra light can hinder you in achieving a consistent and accurate result. Make sure you have enough desk space to move your mouse freely and that you have full access to your keyboard for any shortcuts.

⬆ *Paint Shop Pro X.* ➡ *Make sure your PC is set up correctly and placed in a suitable position before you start.*

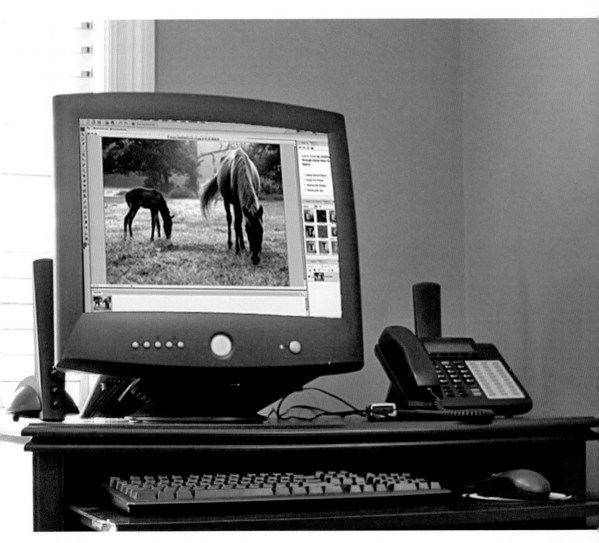

What is Image Editing?

Image editing is altering the appearance of the picture from its original state – this can mean anything from small adjustments that are almost unnoticeable to extreme enhancements that dramatically change the entire image.

Most of the skills in the next few pages used to be achieved in a traditional darkroom, but now you will discover how digital manipulation can be done on your PC.

By using one of the most popular and powerful home-editing software packages, Adobe Photoshop Elements, you will learn how to use tools effectively and apply commands correctly. You will learn to crop creatively, correct colours and tone and remove unwanted details. These techniques will help you to maximize the potential of your images.

The Basics

A digital image is made up from thousands of small squares of colour called pixels. The more pixels an image has, the higher the resolution of the image. When you edit an image on a PC, you are altering these squares of colour by changing their colour or brightness. You can copy and paste them, move them around or even delete them entirely.

Generally you won't see these pixels as separate squares because they are too small. If an image on screen is at 100 per cent magnification, then the pixels displayed will be

➡ Cropping an image isolates a smaller image area and deletes the remaining pixels.

grouped together 72 pixels per inch (ppi) by 72 per inch. This is called screen resolution and is the default resolution for most digital cameras (some pro models will save at a printing resolution of between 200 and 300 ppi). The more megapixels your camera has, the bigger the physical size of the image will be, but its native resolution will stay at 72 ppi unless you change it. A five megapixel image may be made up of 2,592 pixels horizontally by 1,944 pixels vertically. The physical size would therefore be 2,592/72 = 36 in (91 cm) by 1,944/72 = 27 in (69 cm) and would obviously not all fit on your screen at once.

Resizing the image on your PC can compress more pixels into the inch.

If you use the zoom tool, you can enlarge your image enough to be able to see the squares.

Final Destination

It is a good idea to decide the final output for your image. If you try to work on a low resolution image, e.g. a 4 in x 7 in image at 72 ppi, you will find that the pixels are quite noticeable, not only on screen but in the printed version. The more pixels your image has per square inch, the easier it will be to work with.

If you want to print your images from a home printer, then you must have enough pixels contained in your image to give you at least the minimum satisfactory quality. For home printers this is about 150 ppi. You can always size the image down if you want to send it by email, but it is rarely worthwhile to size it up for printing if it is not correct to start with.

➡ *Image editing can improve the appearance of your photographs*

Tools & Palettes

In image-editing software, most of the functions are displayed in little windows called floating palettes. They are movable, so they can be placed anywhere on your screen for ease of use. Everything you need to perform your chosen edit can be found on these palettes.

The first thing you will notice after launching your software is the tool bar palette on the top left-hand side of your screen, the image menu bar along the top and the various palettes running down the right side. This is called the workspace and you can customize it to suit your requirements. You can close palettes which you are not using, and then reopen them using the Image menu > Window or the tool bar.

Palettes

Various functions and commands can be performed from a palette. One of the most popular is the Layers palette – this can build up new parts of an image, one on top of the other. Special effects can be added to an image from the Style palette, and technical help can be reached with the Help palette.

Tools of the Trade

The most important palette is the tool bar, which generally stays open at all times. This group of tools is used directly on the surface of the image and can be accessed quickly by using keystrokes.

One of the most useful tools is the zoom tool, which looks like a magnifying glass. You can use this to enlarge or decrease the display of the image. If you click, hold the mouse

➡ This is what you will see after you have launched your software.

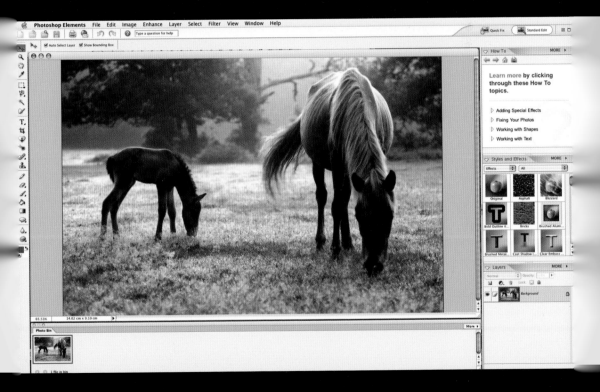

down and drag across the image, you will notice a dotted outline appear – this is called a marquee. This dotted line tells the computer how much of the image to enlarge. When you have enlarged your image, you can navigate around by using the hand tool. Click and drag the hand tool to move the image around the screen.

Selections

The selection tools have small black triangles on their icons. If you click and hold down the mouse on these icons, a small fly-out palette will pop up offering you further options for that particular tool. The selection tools isolate areas of your image that you wish to either work on or exclude.

Cropping & Text

The crop tool is accessed from the tool bar and can cut your image, removing parts that you don't need (see pages 324–26 for more on cropping). The text tool can add words on to your image that can be re-sized and coloured.

Painting Tools

These tools are more for specialist enhancements that may require drawing or painting. Mainly used by designers on illustrations, these artistic tools are used sparingly by photographers because of their obvious effect.

Enhancement Tools

These are the photographer's favourites and are specifically designed for directly affecting the surface of an image. These tools can sharpen or blur specific areas or lighten or darken others. The clone stamp tool replicates parts of the same image area, which is essential if you want to get rid of dust, scratches, or even unwanted telegraph poles (see pages 320–23 for more on using the clone stamp tool).

➡ *The styles and effects palette.*

Removing Red Eye

This is probably one of the most common faults found with flash photography and can seem to ruin an otherwise great picture. With the help of your PC and software you can easily correct this, but you should also learn how to avoid it altogether.

Causes of Red Eye

In typical red eye conditions, the ambient light is dim and because of that the pupil of the human eye will be fully dilated to allow in as much light as possible. The interior surface of the human eye is covered with blood vessels and these cause the red colour when the camera flash enters the eye, bouncing off the back and straight into the camera lens.

Avoiding Red Eye

The way to avoid this is to not use the flash in the line of sight of your subject. For instance if your camera has a hot shoe, use a separate flashgun with a tilting head. This way you can bounce the light from the flash off the ceiling or walls. Or more easily, set your camera to auto red eye. This will send a burst of light from your camera before the main flash and force the pupils to close down before finally taking the picture. This auto function doesn't always work to perfection and you can still end up with unnatural results. So, the only way to correct red eye completely is with your computer.

➡ *Moving the flash source away from the line of sight will cause the reflection to bounce off away from the camera.*

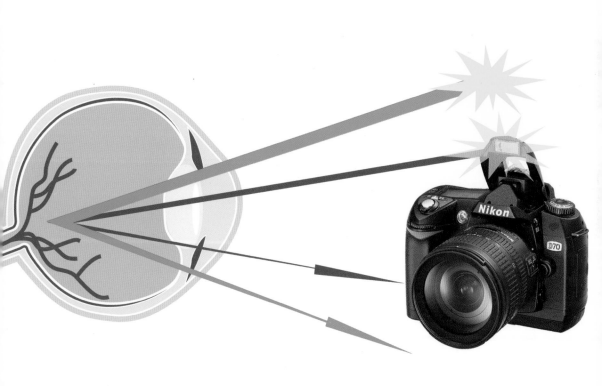

Correcting Red Eye

Nearly all image-editing software packages give you the tools to remove this annoying fault. Normally based on a soft brush shape, this useful tool can reduce the red hue found around the pupils. Remember that when using brush-based tools, you must choose the size of your brush and its softness before you start, making sure that it will fit only within the eye area.

The more popular image-editing software packages such as Photoshop Elements will now give you auto tools to make erasing red eye even easier. Just select the red eye removal tool from the toolbox and click, holding the mouse down, and drag a marquee over the offending eye and the redness will simply disappear.

You can adjust the size of the brush and the darkening strength from the image menu bar by moving the sliders between 0 per cent and 100 per cent. You do need to be subtle when using this tool.

⬆ *Red eye can spoil an otherwise good picture.* ➡ *Select the red eye removal tool from the toolbox and drag a marquee over the eye.*

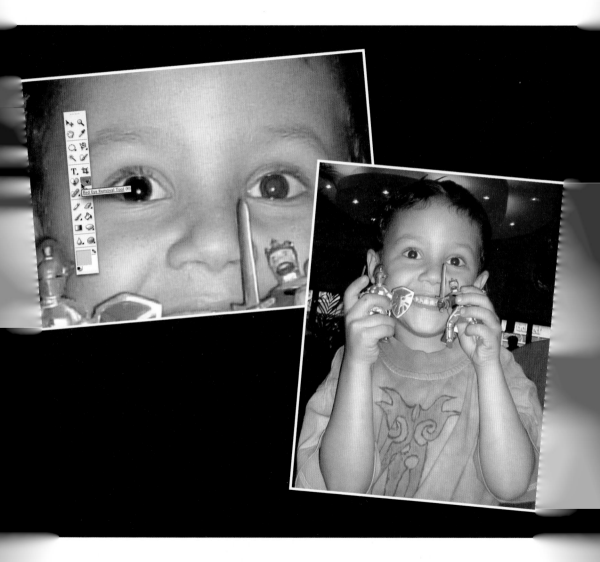

Removing Unwanted Details

It is very frustrating to find that your composition has been ruined by unwanted elements such as telegraph poles and wires or people walking through your shot. All these can be removed with the use of the clone stamp tool. This brilliant tool is also indispensable when scanning in your prints as it can remove dust and scratches and repair tears and rips.

How Cloning Works

The clone tool works by copying neighbouring pixels and laying them over the top of the area you wish to erase. As this is a brush-based tool, it works best when you adjust the brush size continually throughout to suit the area. For fine details, it is advisable to keep the brush as small as possible to avoid obvious repetition of pixels. This is a very powerful tool and needs plenty of practice and patience, but when mastered it can be one of the most effective tools at your disposal.

Take a good look at your image, decide on exactly what needs to be erased and where best to copy the new pixels. Remember that you are replicating existing areas of your image so be aware that it should match as best as you can or it will look obvious.

Step One

Use the zoom tool to enlarge the working area. Now select the clone stamp tool from the toolbar. The tool is displayed on screen as either a cross, to pinpoint the area you are working on, or a circle if you press the caps key on your keyboard, to illustrate the size of the brush.

➡ *This image is fine except for the telegraph poles. They can easily be removed with the clone/rubber stamp tool.*

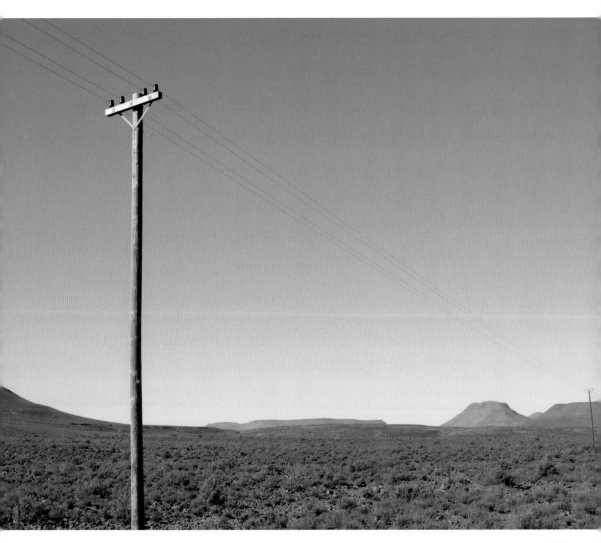

Choose a suitable brush size from the image menu bar by dragging the size slider up or down. You can also select how soft the edge of the brush is from the options area.

Step Two

Move the clone stamp tool over the part of the image you want to copy from. Hold down the control key (option key for Mac) on your keyboard and click in the image. By doing this you are defining exactly where to copy.

Step Three

Either dab or stroke over the area you want to remove. As you move over the image, you will notice another cross following you. This second cross lets you know exactly from

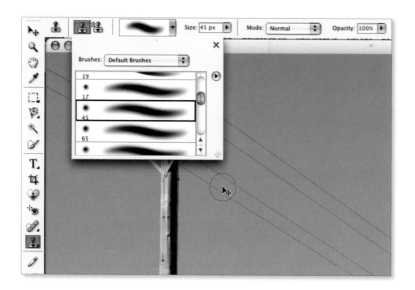

where the new pixels are being picked up. So you can check if you are going too far over the image, as the second cross will show you if you are about to pick up unwanted pixels. Remember that if you do make a mistake, choose Edit > Undo Clone Stamp to undo the last action.

➡ *Select a brush, choose where to copy from and start erasing.*

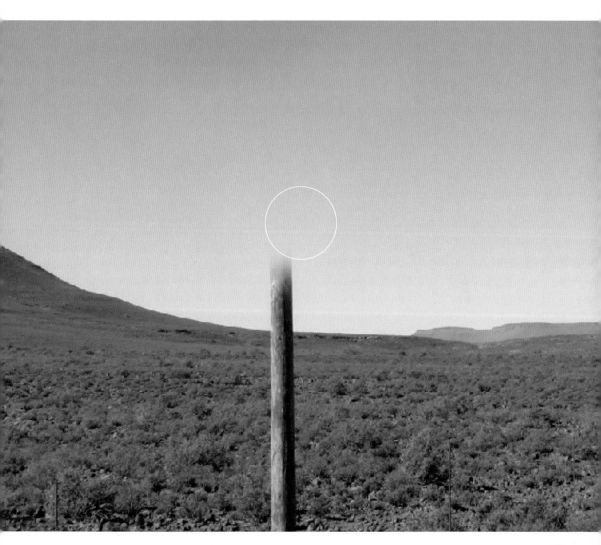

Basic Enhancements: **Crop & Rotate**

Every photographer – from the most experienced to the novice – can improve their photographs with simple cropping and rotating.

Cropping

The majority of image-editing programs – however basic – include a crop tool. It is very easy to use and can make a vast difference to your image. To crop is to retain only a section of an image – a crop can be large or small depending on the effect you want to create.

Why Crop?

On occasion you may want to remove a section or object from your photograph that is spoiling the overall composition, for example a person who has inadvertently walked into shot. Every image-editing program is slightly different, but typically you drag the crop tool over the section of the photo you want to retain and a virtual box appears over the photo. You can then adjust the four sides of the box to fit the area you want to crop, leaving anything you want to remove outside, before finally activating the crop.

The crop tool is a good way of improving a photograph and your composition, enabling you to experiment with different compositions and to see if the overall photo would have been improved if you had left some aspects out, or zoomed in tighter on a certain area. It is also useful as not all digital cameras show 100 per cent of the image area on their

➡ *To crop, drag a box over your image and click the tick icon.*

LCD screens or in their viewfinders. It is worth remembering that every time you crop an image the file gets smaller, as you are literally throwing away image information. This may well affect the maximum size of your prints.

Rotating

The rotate tool is a very useful feature. We have all seen photographs blighted by horizons that are not quite horizontal or pictures of people who seem to be veering slightly to one side. There are several ways of rotating an image – in Photoshop you can specifying the number of degrees and direction (clockwise and counter clockwise) or rotate in increments of 90 degrees. In Paint Shop Pro you can correct a horizon using the straightening tool, whereby you match up a movable line with the askew area and then determine whether you want to straighten the image vertically or horizontally.

The cropping and rotating tools work together – every time you rotate an image you will need to crop it in order to retain its rectangular format; very often you will not be able to see which area of the picture needs cropping until you have performed the rotation.

⬆ *Images can also be improved by rotating.* ⇨ *To rotate, go to the Image menu and select Rotate Canvas.*

Basic Enhancements:
Colour, Brightness & Contrast

There are many reasons why a photograph may not look right - perhaps the day was particularly dull and overcast or perhaps the camera settings were incorrect. Photoshop Elements and Paint Shop Pro have a variety of tools to correct these problems, either automatically, where the program analyzes the image and makes a change, or manually, where you control the adjustment. If you are new to digital photography you can try automatic commands. As you become more experienced you can begin to take more control and make adjustments manually.

Brightness and Contrast

Increasing the brightness and adjusting the contrast between the dark and light tones can make a huge difference to a dull image. In Photoshop make adjustments by dragging sliders left down to minus 100 (to darken) or right up to plus 100 (to

⬆ *Overcast weather can produce a dull shot.* ➡ *Adjusting brightness and contrast can help.*

lighten) an image. Photoshop Elements and Paint Shop Pro both feature a tool that analyzes the photo before adjusting the contrast for you.

How it Works

In Photoshop the Auto Contrast tool is an automatic feature that works by finding the lightest and darkest point of an image and then distributing all the remaining pixels' tones between those two points on the tonal range. In Paint Shop Pro the Automatic Contrast Enhancement offers slightly more flexibility, because you can adjust the bias/brightness (lighter, neutral and darker,) the strength of the adjustment (normal or mild) and the appearance (flat, neutral and bold).

Levels

The Levels command offers a greater degree of control than the brightness and contrast tool. It is able to do this by changing the tonal range of your photograph. It is displayed as a histogram (a vertical bar chart with hundreds of fine bars): the black lines represent the distribution of highlights, mid-tones and shadows across the image. Make adjustments to the entire picture or the individual red, green and blue channels by dragging the black (shadow), grey (mid-tones) and white (highlights) sliders at the bottom.

How it Works

Novices may find it useful to start using the Automatic Levels command found in Photoshop – this tool works by finding the lightest and darkest pixels in each colour channel, converting them to white and black and redistributing the remaining pixels between the two.

➡ Adjust highlights, mid-tones and shadows.

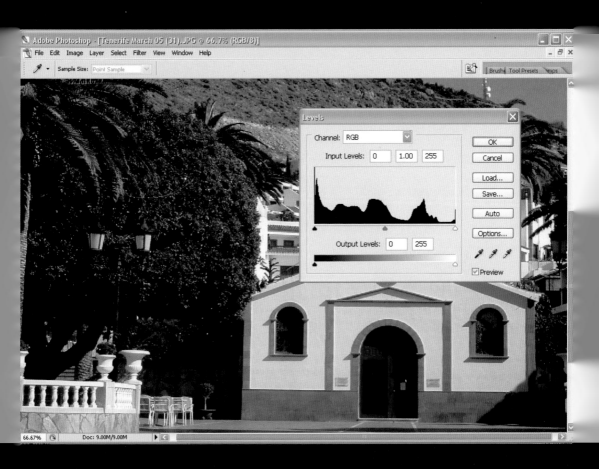

Lenses: **Wideangle/Telephoto**

The quality of lens that you use on your digital camera will affect and possibly limit the quality of image that your camera can produce. If you own a digital SLR, you will be able to buy additional lenses and expand the range of your photography.

Cameras with fixed (i.e. permanently attached) lenses can be made to be more flexible with the addition of supplementary lenses, but your camera needs to have a filter ring or a special adaptor in order to be able to take advantage of these. There are two types of lens: fixed focal length and zooms. Zoom lenses are covered in more detail on pages 336–39.

Fixed Focal Length Lenses

Focal length is a scientific measurement of the distance between two key points in the optical train of a lens. It is meaningless when quoted alone, but when it is used in conjunction with the size of the image area (in practical terms, the size of the sensor), it gives you information about how much a lens will magnify an image and also how much of a scene it can fit in. It is usual to see two figures quoted: the actual focal length, and what focal length would be required to get the same image magnification if the

⬆ *A wideangle photograph.* ➡ *Wideangle lenses literally give a wide angle of view.*

sensor were the size of a 35 mm film frame. So a digital SLR lens may have an actual focal length of 12 mm, but has a 35 mm equivalent of 18 mm. These equivalents are quoted so that you can compare different types of digital camera lens from different manufacturers. Fixed focal length lenses come in one of three main forms, with either short, medium or long focal lengths.

Lens Varieties

The first of these is known as a wideangle lens, as it gives you a wide angle of view (and consequently a small image magnification). A medium focal length lens is often known as a standard lens (as this used to be the lens that came as standard with a new SLR) and will have a focal length of about 50 mm. A telephoto is a higher magnification lens and as the literal translation of its name (far light) implies, it enables you to take pictures of objects far away.

Fixed Focal Length Lens Advantages

Fixed focal length lenses have several advantages. They are less complex to design and build than zoom lenses, and it is therefore cheaper to build a really good fixed focal length lens than it is to build an equivalently good zoom lens. There is also the issue of the maximum aperture. The maximum aperture of the lens determines the maximum amount of light it will let through to the viewfinder and the sensor. A big (known as fast) aperture allows more light through and thus makes it easier to see through an optical viewfinder and check focus and composition, which is particularly useful with wideangle lenses. It also allows you to blur backgrounds more easily, which is useful for telephoto lenses. Finally it allows faster maximum shutter speeds to be used, which is useful for any lens.

➡ *Telephoto lenses have higher magnification.*

Lenses: **Zoom**

At one time zoom lenses were an expensive curiosity. Now they are by far the most popular kind of lens found in photography - whether on compact digicams or on digital SLRs.

The focal length of a zoom lens can be varied in order to aid composition. In theory, a zoom lens is one that does not require refocusing after its focal length has been changed, while a varifocal is one where you do need to refocus. In practice, whilst many zoom lenses do need refocusing, this job is taken care of by autofocus systems, so it may not be obvious which type of zoom lens you have.

Technical Information

Like fixed focal length lenses, the focal length of zoom lenses determines their image magnification and angle of view. They are always shown as two figures: the minimum and the maximum focal length. For example, 28-70 mm describes a zoom with a minimum focal length of 28 mm and a maximum of 70 mm. This kind of lens is either known as a wideangle zoom (as its minimum focal length is

⬆ *Zoom lenses are a very popular accessory.* ➡ *This first image shows Big Ben, London, in the distance behind a statue.*

a wideangle one) or a standard zoom, as its focal length range includes 50 mm. You might also see this kind of lens described as a 3x zoom, as its maximum focal length divided by its minimum focal length is about three. A 35-420 mm lens would therefore be known as a 12x (420 divided by 35 = 12). This is known as a telezoom (as it includes telephoto lengths) or as a superzoom as its zoom ratio is over 6x. You are unlikely to find a lens of this kind as a digital SLR lens, as their sensors are bigger and this would be a huge piece of glass to carry around.

Lens Varieties

Like fixed focal length lenses, different zoom types are useful for different kinds of photography. It is therefore useful to have a range of different focal lengths available. The less ambitious the zoom range the easier it is to make a good lens, but bear in mind that you will have to buy more lenses to cover the same focal length range as a superzoom.

⬆ ➡ *The second image (left) and the third image (right) show the difference a zoom lens can make.*

Maintenance

Digital cameras are very much like cars in terms of how you can best ensure their long-term survival. They work better with a little maintenance than with none, but tinkering is not advised.

It is quite easy to break a digital camera, or at least render it useless, which is not quite the same thing. Dropping a camera repeatedly can lead to problems such as the shutter release button working loose and even falling out, while sticky sliding lens caps are another common problem resulting from too much wear and tear. If your lens cap doesn't get out of the way of the front element of the lens, you cannot take pictures. This kind of thing often happens when cameras are incorrectly stored (in a tight trouser pocket, rather than on a strap or in its own bag), or used in adverse situations – on a windy day at the beach, for instance, or by children with sticky fingers. Sand and seawater in particular can be fatal to a digital camera. If sand gets into your lens it will cause trouble sooner or later, and if seawater gets into your electronics you will probably already have lost the use of your camera.

⬆ *Use a specialist lens-cleaning kit.* ➡ *Take care at the beach - sand and seawater are bad news for cameras.*

Avoiding Damage

Regular maintenance can help you, however. If you get into a sensible cleaning routine at the end of a day's shoot, you can avoid these camera disasters. Cleaning includes checking that there is no sand or moisture in your camera bag, either. There is no point in cleaning the camera and then putting it into an even more hostile environment than you have used it in.

Cleaning Methods

First, blow any extraneous matter off the camera before you start cleaning. Pay special attention to the lens barrel, and in the event of a digital SLR, to the lens mount and mirror box. Always hold the camera so that you are blowing dust or dirt down and off rather than up and into the camera. Using a blower brush means that you won't be blowing small amounts of saliva on to your camera.

For the lens and, specifically, the front element, first brush, then blow and only then, and with a special lens-cleaning cloth, sweep the lens radially (down) rather than in a circular motion. Give any hard matter a chance to fall off rather than being ground in.

Check in on Your Camera

Finally, always make sure that if your camera is stored somewhere other than on your person for a long period, that the batteries are kept outside. Batteries left too long can leak and corrode the contacts, and equally importantly the on/off switch may get accidentally pressed and cause the camera to open in a confined space, damaging the lens irreparably.

➡ *A blower brush and lubricant are useful accessories.*

Making Use of the Internet

Whether it is news, views or online printing, the internet is packed with useful information about digital photography. Many websites boast discussion forums and online galleries where you can display your photographs. Others offer printing facilities at competitive prices so shop around to ensure you get the best price. Some sites even offer free prints or online storage if you sign up, but beware of hidden costs.

www.amateurphotographer.co.uk
The UK's longest-running photographic magazine has a strong online presence with regularly updated news pages, forums and reader photos.

www.bonusprint.com
Reasonably priced digital processing on a wide range of conventional, traditional and digital print paper sizes, with price reductions for buying in bulk. Bonusprint can also print on to a range of other media including mugs, cards, photo books and t-shirts.

www.ephotozine.com
While a good source for the latest news, undoubtedly the highlights of ephotozine are the reader galleries and portfolios, which have the feel of a real online community.

www.imaging-resource.com
From news, camera reviews and photo galleries, to forums and useful lessons on photographic technique, Imaging Resource contains a little bit of everything.

www.jessops.com
High street photography retailer Jessops has a user-friendly website, offering prints at a range of

different sizes and gift formats at mid-range prices. By registering you can store your photographs in an online album.

www.kodakgallery.com
The Kodak EasyShare Gallery offers a good selection of printing sizes at reasonable prices as well as photo books and cards. The layout is straightforward and there is free online photo storage for registered members.

www.luminous-landscape.com
With emphasis on the genre of landscape photography, Luminous Landscape has some great essays along with reviews, news and tutorials.

www.pbase.com
One of the foremost sites for photo-sharing on the Internet. For a yearly fee you can obtain 300 MB of storage and create your own gallery.

www.photobox.com
As well as having a superb online gallery, Photobox frequently wins awards for its photo printing service. Prices are reasonable and you can print on to a wide range of paper sizes as well as an extensive selection of gift products.

www.pocket-lint.com
News and reviews on the latest 'gadgets, gear and gizmos', including software, phones and digital cameras, presented in a user-friendly format.

www.steves-digicams.com
This US-based site contains extremely detailed reviews of masses of digital cameras (past and present), printers and accessories.

www.whatdigitalcamera.com
The website for one of Britain's best-selling digital photography magazines, containing regularly updated news, test pictures from the latest issue, downloadable tutorials and reader photographs.

Bibliography

Ang, Tom, *Digital Photography: An Introduction*, Dorling Kindersley, 2003

Ang, Tom, *Digital Photographer's Handbook*, Dorling Kinderlsey, 2004

Busch, David, *Digital SLR Cameras for Dummies*, Hungry Minds Inc., 2005

Freeman, Michael, *The Digital SLR Handbook*, Ilex, 2005

Freeman, Michael, *The Complete Guide to Digital Photography*, Thames & Hudson, 2003

Freeman, Michael, *Close-Up Photography: The Definitive Guide for Serious Digital Photographers*, Ilex, 2004

Freeman, Michael, *Black and White: The Definitive Guide for Serious Digital Photographers*, Ilex, 2005

Gartside, Tim, *Digital Night and Low Light Photography*, Ilex, 2006

Johnson, Dave, *How to Do Everything with Your Digital Camera*, Osborne McGraw-Hill, 2005

Johnson, Harald, *Mastering Digital Printing*, Premier Press, 2004

Lacey, Joël, *The Complete Guide To Digital Imaging*, Thames & Hudson, 2002

Lacey, Joël, *The Digital Darkroom: A Complete Guide to Image Processing for Digital Photographers*, RotoVision, 2004

Lacey, Joël & Henshall, John, *Going Digital: Wedding and Portrait Photography*, RotoVision, 2003

Peterson, Bryan, *Understanding Digital Photography: Techniques for Getting Great Pictures*, Amphoto Books, 2005

Rouse, Andy, *Digital SLR Handbook*, Guild of Master Craftsman Publications, 2005

Weston, Chris, *Mastering Your Digital SLR: How to Get the Most Out of Your Digital Camera*, RotoVision, 2005

Weston, Chris, *Digital Wildlife Photography*, Guild of Master Craftsman Publications, 2005

Picture Credits

All images courtesy of Alan McFaden, Nigel Atherton (www.nigelatherton.com), Hannah Bouckley, Ian Burley (www.dpnow.com), Steve Crabb, James Goulding, Jamie Harrison, Nick Wells and Andrew Harris (www.andrewharrisphotography.co.uk). Except the following:

Boots: 246; Foundry Arts: 216; HP Manufacturer: 245

Used under license from Shutterstock.com and © these photographers: 3 and 133 Marzipana; 10 GraÃ§a Victoria; 13 Teeratas; 16 Wutthichai; 20 Planner; 24 OtnaYdur; 31 Matt Valentine; 33 Yen Hung Lin; 34 jocicalek; 41 Natalia_R; 43 Coprid; 49 upthebanner; 74 Jose Gil; 77 Natalia Macheda; 82 Josh Anon; 94 Felix Mizioznikov; 99 Marzipana; 100 Fairy Lens; 129 Jim Parkin; 131 Tracy Whiteside; 157 Mircea Bezegheanu; 181 Milos Luzanin; 187 JohnKwan; 188 Maksym Protsenko; 192 Luciano Mortula; 203 Darren Hubley; 218 Eprom; 219 Niar; 221 Morgan DDL; 231 Nikolay Mikhalchenko; 232 Sven Hoppe; 250 KUCO; 252 Pavelis; 260 Color Symphony; 263 luchschen; 269 iDesign; 271 scyther5; 280 wawritto; 282 BearStock; 286 1000 Words; 297 Utflytter; 299 Otna Ydur

Authors

Nigel Atherton is currently the Editor of *What Digital Camera*, the UK's oldest digital photography magazine. Originally from Bath, Somerset, Nigel became interested in photography during his last year at school. After a year assisting a local photographer he studied photography, film and TV production at Plymouth College of Art and Design. In 1984 he became a cruise ship photographer, during which time he visited around 40 countries and supplied travel photography to a major stock library. On returning to the UK in 1990, Nigel worked as a ballistics and weapons photographer for the Ministry of Defence, then as technical helpline manager for a major camera manufacturer before continuing his photographic education at the University of Westminster. He joined *Amateur Photographer* magazine as a technique writer in 1994, and was Features Editor from 1998 to 2001. After spending a year publishing photography books he became Editor of *What Digital Camera* in 2002. He lives in Brighton with his wife and two children.

Hannah Bouckley has been a keen photographer since she was a child and has continued to enjoy taking pictures ever since. She discovered Photoshop while studying for a Media Production degree at Bournemouth University, where she gained a 2:1. On graduating she contributed to a range of photographic titles, including *Digital Photography Made Easy*, *Digital Photographer* and *Digital Camera Buyer*, before moving to *What Digital Camera*, the UK's original digital photography magazine, in 2005. She is currently Reviews Editor on T3 magazine, a role that puts her in the enviable position of trying out the latest digital cameras.

Ian Burley was hooked on photography by the age of ten and, from then on, regularly badgered his parents to buy him a darkroom. Later, Ian ran the school photographic society and spent summer holidays helping out at the local camera store. After studying computer science at degree level in the early 80s, Ian went back to the same camera store and was managing it within a year. He later managed the company's flagship store in north London, winning the Amateur Photographer Dealer of the Year Award in the process. By the mid-80s Ian had settled into a longer term career as an IT journalist. The advent of digital imaging neatly married Ian's passion for photography and IT skills. Since 2000 his writing has been primarily in the field of digital photography, and in 2001 he launched his Digital Photography Now website (www.dpnow.com). Ian thinks his two young daughters are probably the most photographed kids in the world, though some of his colleagues who also contributed to this book just might disagree.

Steve Crabb studied photography at Bournemouth & Poole College of Art in 1986. He has worked in the media industry for nearly twenty years and has produced Photoshop work for clients such as Yahoo, The Body Shop and the Football Association. He is currently the Art and Tutorials Editor for *What Digital Camera* magazine and has co-authored several other books on digital photography and Adobe Photoshop.

Jamie Harrison has been a professional photographer and printer for over twenty years, working in most disciplines. His experience covers everything from social photography on cruise ships to weddings, advertising and corporate photography. As a black and white and colour printer, he has produced work for many commercial clients and was also the main printer for the British Film Institutes archive. In 1997 he discovered Adobe Photoshop and began working with Apple Macintosh computers and digital scans. He joined *Amateur Photographer* magazine soon after and began reviewing both film cameras and digital cameras. A former Technical Editor of *What Digital Camera*, he has tested most of the digital cameras released in recent years, as well as writing tutorials on photography and Adobe Photoshop. Jamie has also appeared on TV and radio, and has written about photography and cameras for several national newspapers and magazines.

Joël Lacey is a former Editor of *What Camera?* magazine and has been writing on photography since 1981. He has been short-listed for the Periodical Publishers Association Specialist Writer of the Year award and is the former technical editor of Amateur Photographer magazine. Joël has written three books on digital photography including *The Complete Guide To Digital Imaging* (Thames & Hudson), *The Digital Darkroom: A Complete Guide to Image Processing for Digital Photographers* (RotoVision) and (with John Henshall) the award-winning *Going Digital: Wedding and Portrait Photography* (RotoVision). He currently lives in rural Dorset with his wife, his dog and a garden full of chickens.

Index